CATS
Drawing and Painting in Watercolour

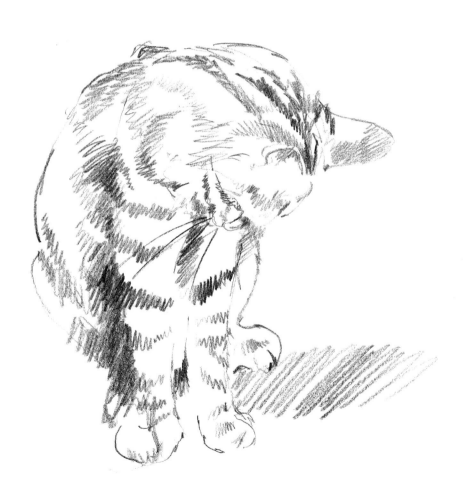

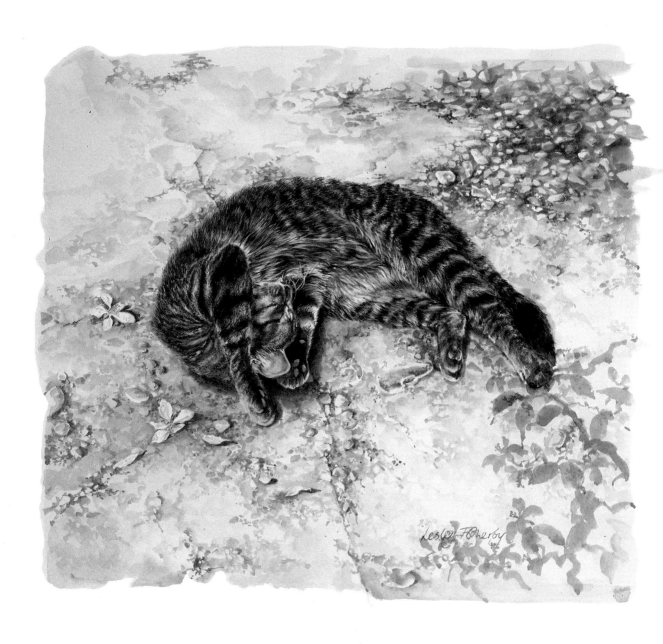

CATS
Drawing and Painting in Watercolour

LESLEY FOTHERBY

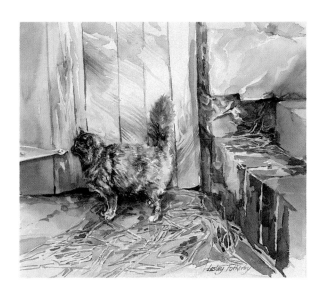

Michael O'Mara Books Limited

First published in Great Britain in 1993 by
Michael O'Mara Books Limited
9 Lion Yard
Tremadoc Road
London SW4 7NQ

A CIP catalogue record for this book is available from the British
Library

ISBN 1-85479-163-X

Edited by Alex MacCormick

Printed and bound in Hong Kong
by Paramount Printing Group Limited

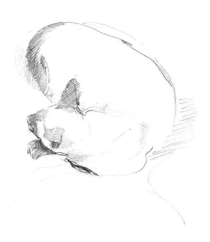

Contents

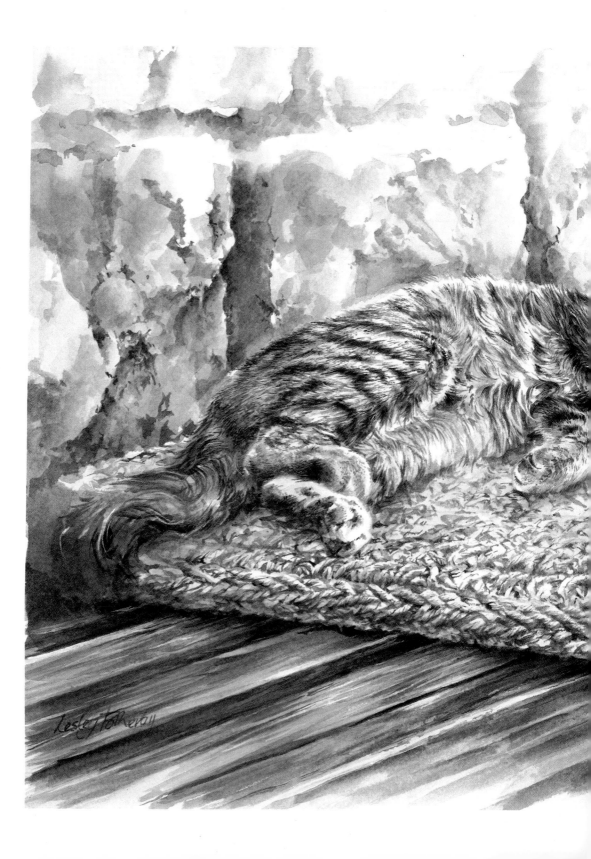

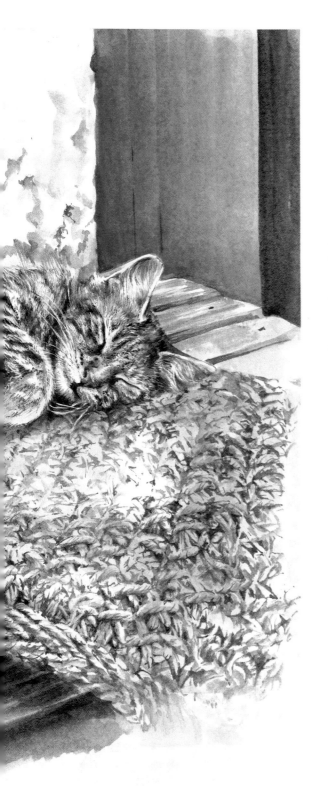

General Introduction

Cats are fascinating to watch and most cat lovers would like to capture something of their pet's grace and elegance on paper. If you have never painted or drawn before, it might seem over-ambitious to begin with a subject which is almost pure movement, but this book shows you how it can be done. Even when a cat is resting on a warm windowsill or asleep by the fire, it is still so alive that it makes sketching a challenge and a delight.

For many years I have been teaching people without any previous experience of drawing or painting to do what I enjoy most: to transfer what I see on to paper. I love watching my two Burmese acting out all the drama of their lives as though they were in the wild. The way they move, how they chase and pounce or simply relax is wonderful to observe. We cat lovers can immediately recognize a change of mood by the way our cat shrugs its shoulders or

pushes back its ears. We consider the whole animal, and read the language of its body.

In other words, when we begin to sketch our cat, we are not starting from nothing. Whether we realize it or not, we have an intimate knowledge of its physical characteristics. Even stroking cats will give you an instinctive feel for the contours of its body and will point to the way to how it should be drawn.

Many people feel that being able to draw is a gift and that either you can draw or you can't. It is true that some will find it easier than others, but in fact drawing is a skill which can be learnt like any other. As with other skills, it can only improve with practice, so do not be discouraged if your first efforts are unsatisfactory. By doing the drawing and looking at it you will be learning, and, as I will be explaining later, do not rip up your paper in frustration merely because you do not like the first lines and shapes you make on it. You will see how I work over and through 'mistakes' so that they become part of the picture.

As you will see from the contents page, I am going to take you step by step from choosing your materials through to a finished drawing and then on to painting with watercolours. But before all this, let's dive in the deep end. Learning to draw is a bit like learning to swim: you can stand on the side of the pool and listen to a lecture or you can jump in, wearing your lifejacket of course, and feel the element around you. Then you understand what they are all talking about. So, without more ado, let's begin.

Drawing

Choosing Your Materials

Whatever drawing implement you choose to use – be it charcoal, pen and ink or pencil – that tool will dictate to a large extent the type of drawing you produce. With charcoal you must inevitably make broad strokes and you can more easily put in solid areas of shadow and lift out highlights. You can achieve great tonal range (of lightness and darkness) just by altering the pressure of charcoal on paper. With pen and ink, on the other hand, you will be forced to think more of the linear qualities of your subject; tonal changes have to be built up more painstakingly by cross-hatching. Once a line is put down in pen and ink, it can't be removed and this will affect how you approach your drawing.

 If you are aware of the materials you are using and are sensitive to them, their different qualities will help you to discover new things to look for in

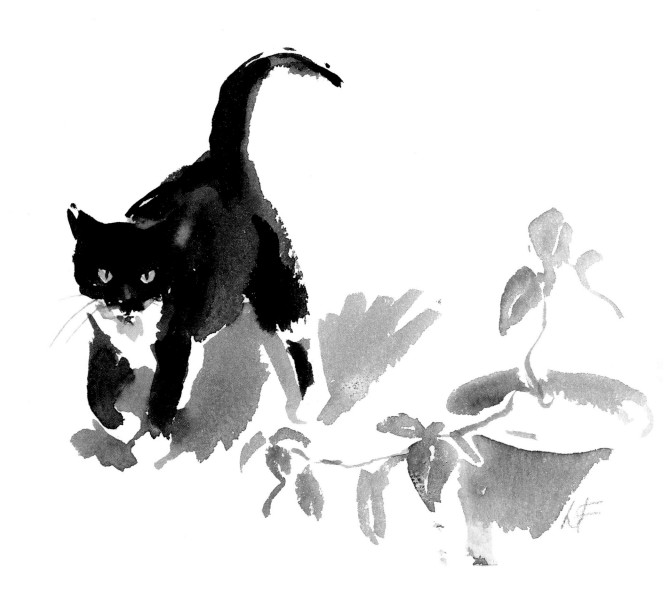

your subject and, by experimenting with different mediums, your drawings will remain fresh.

Anything which makes a mark on a piece of paper can be used for drawing. On pages 12–23 I note some of the most common and most useful.

Paper

You can use any paper which you have to hand to draw on, from the backs of envelopes to brown wrapping paper (which is, indeed, very good). All papers have different surfaces from smooth to highly textured, and the type of paper you choose will affect how your drawing looks. Charcoal on a textured pastel paper will give a more broken and grainy line than charcoal on a smooth bond paper. Here are some examples of reliable and easily obtainable papers:

Cartridge paper: A good general purpose drawing paper for all media, but particularly for pencil because it has a smooth surface. You can buy it in sheets or in sketch-books of various sizes.

Bond paper: Also smooth and obtainable in sketch-books. The one I have used is creamy white and comes from a hardback Daler-Rowney book, which is very convenient to use if you're moving around sketching.

Layout paper: Thin, white, quite transparent paper available in pads with many sheets – useful if you want to do lots of sketches.

Pastel paper: The two types I have used are Ingres and Mi-Teintes – both have pleasing textures. The surface of Ingres is made up of close parallel lines, and Mi-Teintes has a honeycomb finish. These can be bought in sheets or pads, but, if you're thinking of buying a sketch-book of pastel paper, make sure you like all the colours in it first, otherwise you will waste a lot. You may prefer to pick colours you like and buy large separate sheets.

Watercolour paper: This can be used for drawing on. Hot-pressed paper has a smooth surface, which is good for pencil and ink. Cold-pressed 'not' surface paper has a textured surface – I like to use pencil and conté on this. (More about watercolour paper in the painting section.)

On the covers of some sketch-books you will see the paper described as 'acid free'. This means the paper will not discolour with age and it is worth considering if you want to keep your drawings.

Pencils

These come in varying degrees of softness and it helps to think of them on a scale with HB in the middle.

6H 5H 4H 3H 2H H F HB B 2B 3B 4B 5B 6B

(I have included F pencils on the scale because I will be discussing their use later in the book, in the painting section.) Hard pencils on the left-hand side of the scale give a fine but light line. A hard pencil is good for technical work and mathematical drawing because the lead will remain sharp and give great accuracy, but it indents the paper. Also, because the line is light, you will not be able to achieve the range of tone which you need for drawing. So use the pencils on the right-hand of the scale.

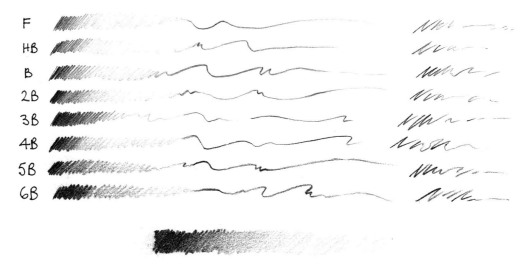

Tone means how light or dark an object appears to be, regardless of its colour. The greater the range of tone you can achieve, the more interesting your drawing will be.

While you are drawing, keep your pencil sharpened or you will lose the 'bite', by which I mean the ability to vary the thickness of the line and consequently the interest of the line.

Conté Sticks

These are hard crayons and can be bought in a wide range of colours, but of most interest to us here are the black, the white and the range of greys and browns (see p. 15).

Conté sticks give a softer line than pencil and are particularly good used on white textured paper such as 'not' surface watercolour paper and pastel paper. The sepia is slightly softer than the black conté.

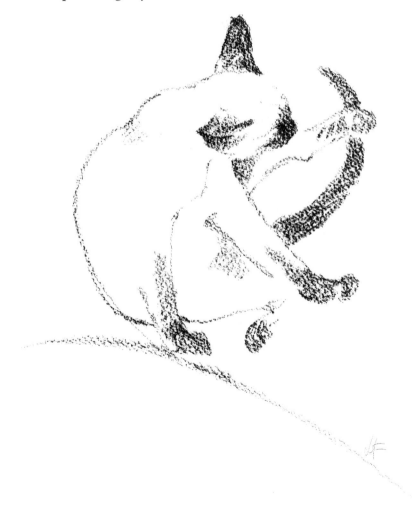

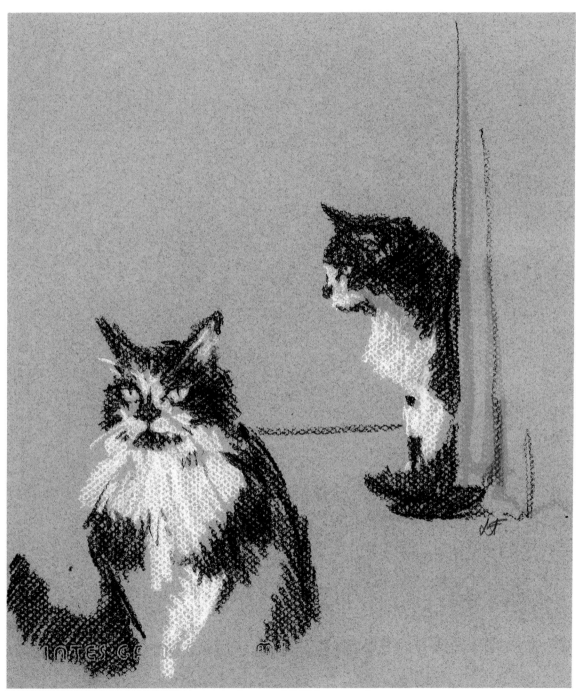

Above and opposite: Various conté colours on Mi-Teintes pastel paper.

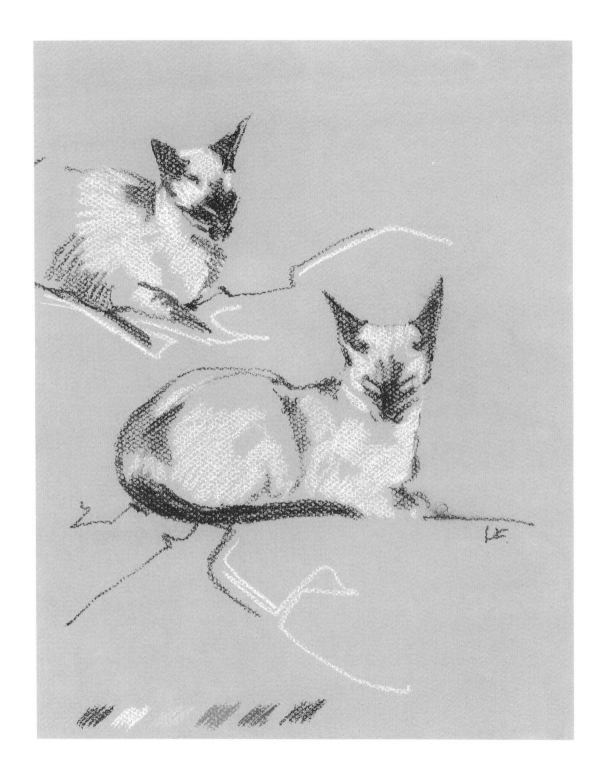

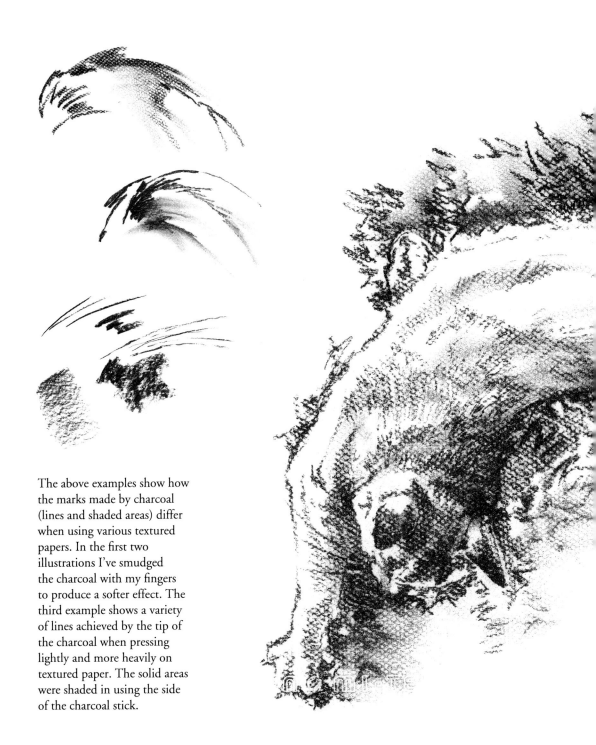

The above examples show how the marks made by charcoal (lines and shaded areas) differ when using various textured papers. In the first two illustrations I've smudged the charcoal with my fingers to produce a softer effect. The third example shows a variety of lines achieved by the tip of the charcoal when pressing lightly and more heavily on textured paper. The solid areas were shaded in using the side of the charcoal stick.

Charcoal

This is very soft and messy (which people either love or hate); you can use your fingers to smudge the lines and obtain lovely soft effects. Beware of using it on hard textured paper, because the sound it makes will attract any cat you are drawing and they will immediately want to investigate.

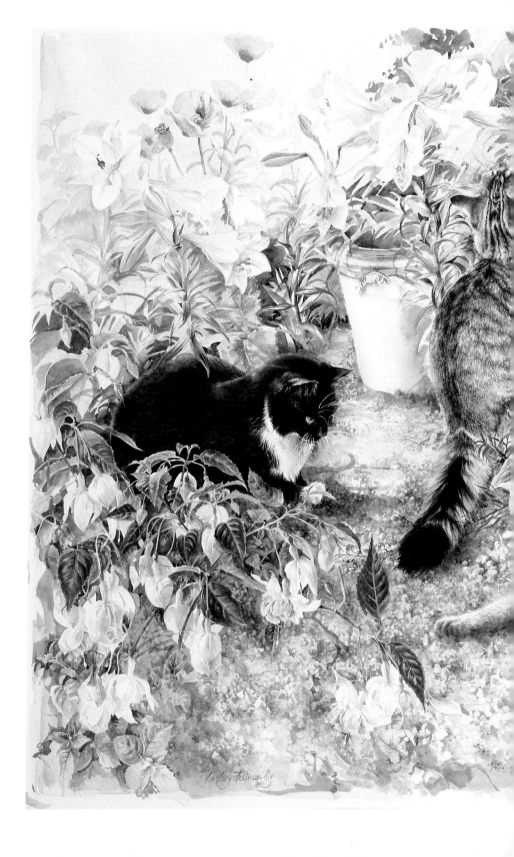

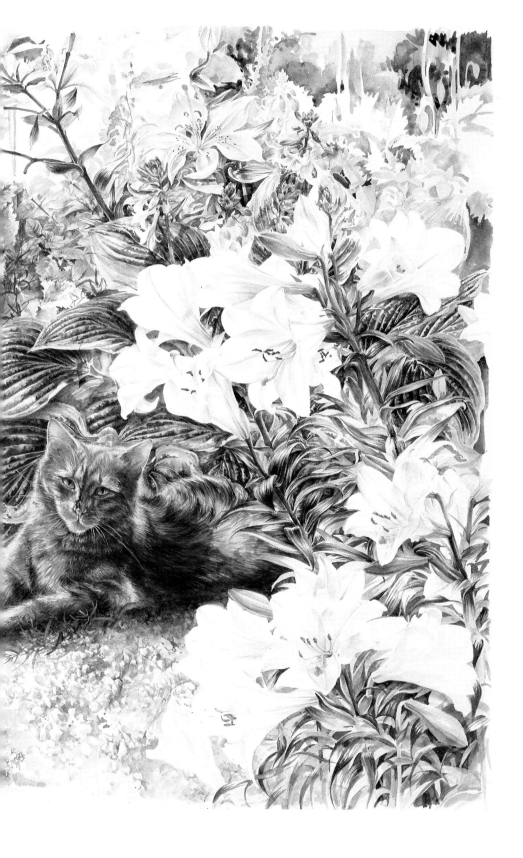

Pen and Ink

Dip-in pens and Indian ink are, in my opinion, the best to use for drawing because you can vary the thickness of the line by how much pressure you put on the nib. The drawings on the left and opposite show how versatile these pens are and how varied are the marks which can be achieved with them.

Technical drawing pens like rapidographs and the disposable roller-point pens make lines which are more uniform, but you can break the line to achieve textural effects and such pens are easy to use and transport. If you want to pick something up quickly and not have to worry about juggling with bottles of Indian ink, they have definite advantages.

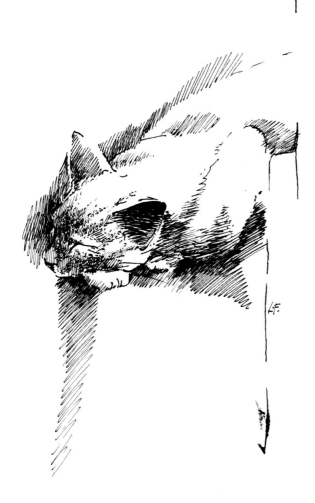

Fountain Pens

The two drawings overleaf (pp. 22–23) were done of one of our cats, Solomon, while he was asleep on my knee. The one on this page is drawn using a fountain pen with a broad nib. I have broken the line to give an indication of the texture of the fur and I've shaded part of the head and some of the background. I've started to play around with positive and negative shapes – the white of the body against the black of the background and the black of the head against the white of the background.

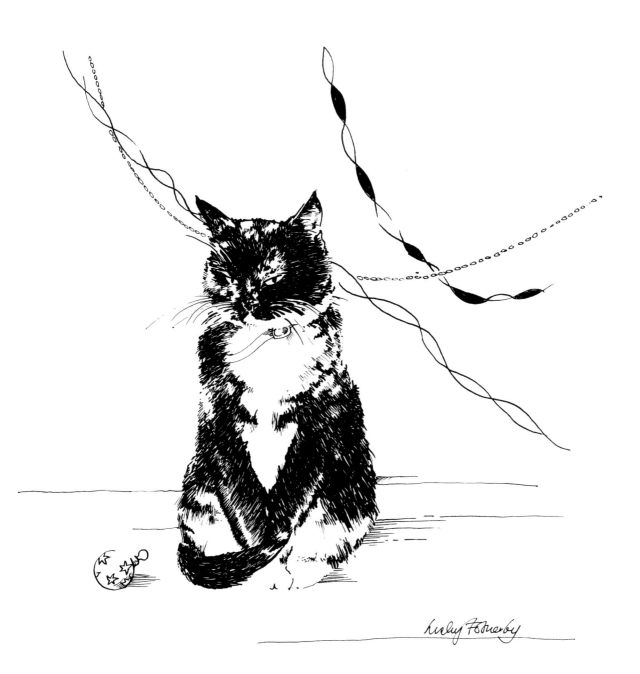

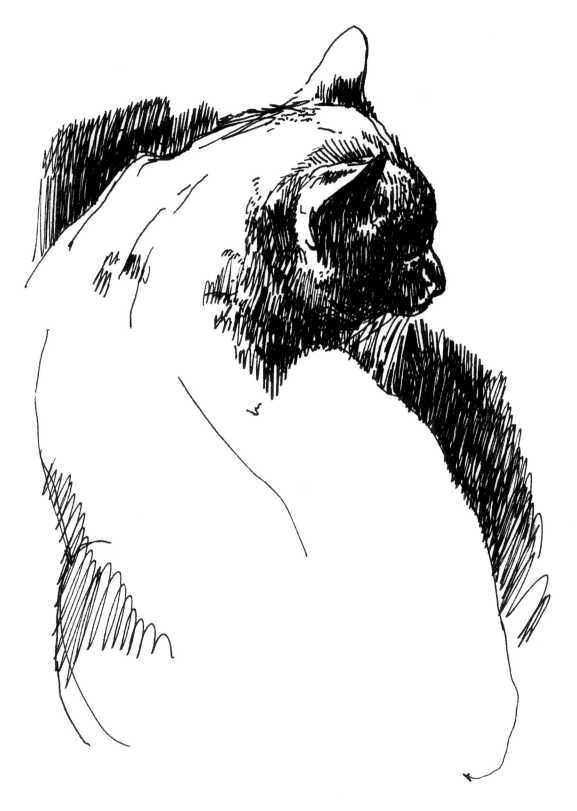

If you place an object so that it is partly seen against a light background and partly against a dark one, you'll see that your judgement of how dark or light that object is will change according to whether the bit you are looking at has dark or light behind it. This changing interplay between foreground and background adds interest to a drawing as we start to see shapes which we weren't originally aware of.

Line Pens

For this drawing I have used a disposable drawing pen which gives a fine consistent line. It is very fluid as you don't have to break off to dip it in ink and it doesn't have a flexible nib (which gives a thin and thick line) like a fountain pen. These characteristics govern the type of drawing produced.

I have concentrated on the outline and not attempted to use shading or to achieve a 'solid' effect. You will see, however, that you can still put over the information you want and convey the feeling of a substantial, muscular animal with just line drawing.

How to Draw

Many people feel that you can either draw or you can't and that the ability to draw is a gift given only to a few. Well, it's true that some people find drawing easier than others, but, as I said earlier, it is a skill which can be learnt by everyone and a skill which improves with practice. So I suggest you start by getting some paper, any sort will do – bond paper, layout paper, writing paper, preferably something not too expensive, then you can put it aside (don't throw it away) without feeling that the paper is too precious to have made any mistakes on – and a pencil, 2B, 3B or 4B. Forget about an eraser at this point as it will inhibit you.

Hold the pencil in your hand as if you were about to start writing. Rest your hand and your lower arm, below the elbow, on the sheet of paper. Relax your hand so that the pencil is being held very loosely. Let the weight of the pencil pull your hand down into position so that the pencil point is on the paper. Now you will have to hold the pencil a little more tightly in order to control it, but don't grip it hard and keep your arm relaxed on the table.

Draw a smooth, continuous curving line across the paper moving just your wrist and your elbow in semi-circles. Then go on drawing more curving lines, still keeping your arm resting on the table, but moving your fingers as

well as your wrist to control the pencil. See how this changes the thickness of the line.

If you are concentrating solely on the point of the pencil as it touches the paper and on holding your hand and arm above the paper, you will find that not only do you tend to grip the pencil too hard but also that you will have to control your elbows and shoulder as well as your fingers and wrist. While you are getting the 'feel' of what you are doing, this can lead to a rather stilted approach to drawing a line, so let the working surface help you by steadying and supporting your arm.

Of course it is all very well being relaxed and ready to start on your cat if it is conveniently at hand. However, a cat seldom does anything for anyone's convenience but its own and it is unlikely to curl up on the edge of your table and wait to be drawn. I have sat at the tables and on the floors of many long-suffering friends, drawing their cats. Sometimes they are off somewhere else, leaving me wondering why I don't stick to still-life. On one occasion I arrived at the home of a cat-owner who was out but had left me a key to get into the house, where I found a note next to a tin of cat biscuits which said, 'If there are no cats around, shake this tin!' That is all very well, but you don't want to start off by drawing a group of ravenous cats racing towards a tin of biscuits. Therefore keep handy some paper, your pencil and a piece of board or a sketch-book to lean on so that, when your cat comes in and settles down to sleep, you can sit somewhere close by and draw. Don't try to follow the cat around – let it settle where it wants and only then move in.

Think of the curved lines you have been drawing and look at how the cat is curled up or stretched out. Try to follow the outline of the body or the backbone, if you can see it, and note how this line follows round to the tail at one end and to the position of the head at the other. Try to put this line down freely. If it's not in quite the right place, don't rub it out – draw another one near it or on top of it which you think gives a better representation of the shape. That first line, even if it is wrong, gives you a mark to compare the next line to, so that you can feel your way to the final drawing. If you keep rubbing out a wrong line, you're starting with a blank piece of paper each time and consequently the same problem – where to put the first mark.

The drawings overleaf, for example, show more than one line describing

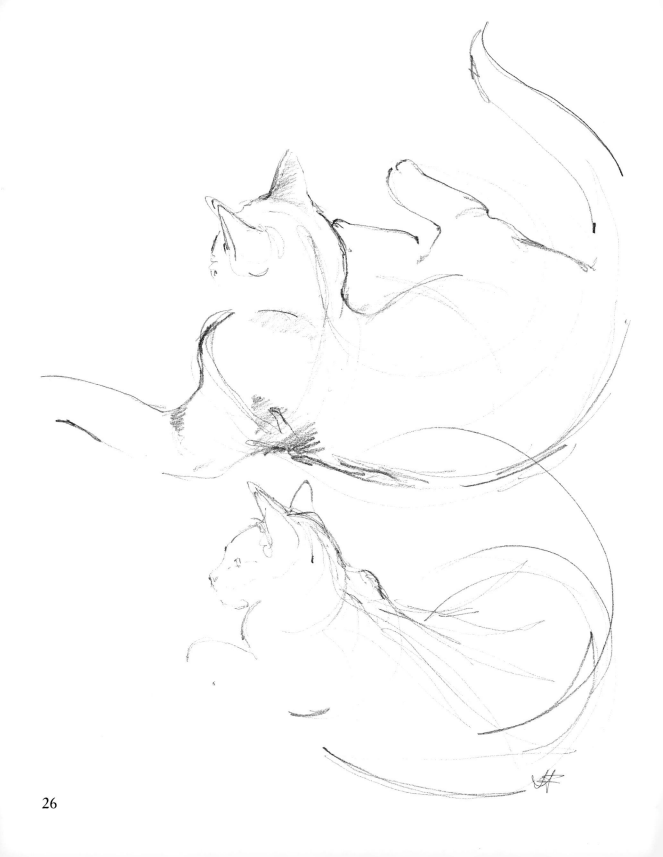

the shape of the cat's body and her ears, but our eye is not really confused by all these marks – we know which ones to 'read'.

In these drawings I have varied the thickness of the lines, just as you changed the lines you drew, by increasing or decreasing the pressure on your pencil. This variation gives the line interest and adds emphasis to certain parts of the body as in the powerful shoulder in the top drawing opposite.

This cat was curled slightly when I drew her and, as you can see, although the back of her body remained fairly still, her head and shoulders moved as I was drawing and I was presented with two poses. In each the body is foreshortened (going away from us), whereas the head and shoulders are viewed coming into profile. This presents a problem – how to put together different parts of the body seen from different viewpoints. To help make some sense of this we need to imagine the line of her backbone drawn in over her fur so that it runs along her spine, over her head and down to the tip of her nose. Then we can see where the centre of her head is and set her ears at the correct angle to this line.

Look at the sketches below and see how this imaginary line twists over the cat from the tail to the nose and helps make sense of how one part relates to another.

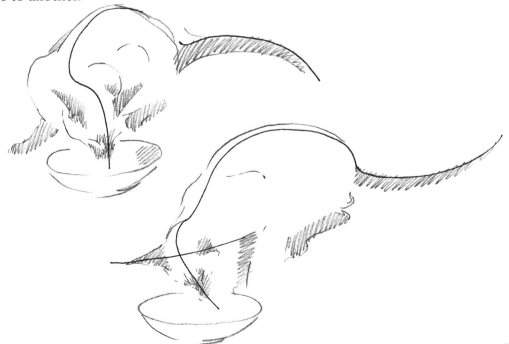

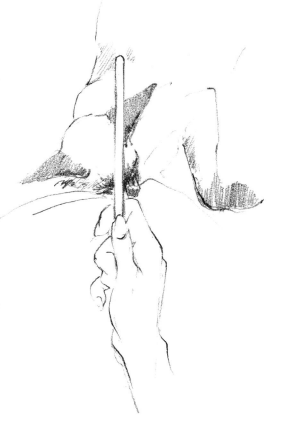

This line is easy to trace along the backbone and tail, but sometimes it is difficult to ascertain at what angle it continues over the cat's head, particularly if you are faced with a pose where the body is viewed in profile, but the head is seen from the front, as in the drawing below. How do you decide what is the right angle to bring it down the centre of the head and fix the nose in position?

When your cat is curled up asleep, sit down with your sketchbook and pencil in front of it. Sit at least an arm's length away and in a position where you can see its head from the front; it doesn't matter about the position of the rest of the body. Take your pencil and hold it upright at arm's length, making sure your arm is straight out and not bent at the elbow; hold the pencil at the bottom and, so that you can see the cat beyond it, line it up with the tip of the nose; now move the top of the pencil over to the left so that it is positioned half way between the two ears (keep the bottom of the pencil on the nose).

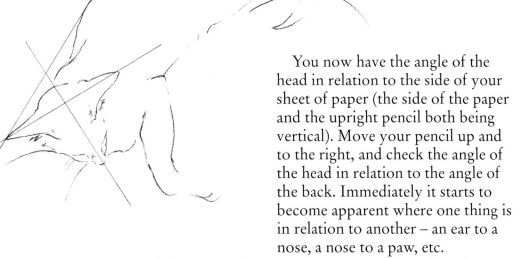

You now have the angle of the head in relation to the side of your sheet of paper (the side of the paper and the upright pencil both being vertical). Move your pencil up and to the right, and check the angle of the head in relation to the angle of the back. Immediately it starts to become apparent where one thing is in relation to another – an ear to a nose, a nose to a paw, etc.

If the cat moves while you are drawing, don't worry – you don't have to get every detail into the sketch for it to make sense. Now move across your paper or on to another sheet and make another drawing and another.

Using your pencil as a line of reference or as a sort of ruler can also help you judge proportions. Suppose you want to know how big your cat's head is in relation to its body: take your pencil and hold it, as before, at arm's length in front of the cat (it is particularly important when gauging the size of one thing in relation to another not to bend your arm at all, always keep the pencil the same distance from your eye) and, with the top of the pencil lined up with the top of the cat's head, slide your thumb up the shank of the pencil until the tip of your finger nail is at the point where you see the chin.

Now you have marked on your pencil a length for the head and you can compare that length with the body. Keeping your arm outstretched and your thumb in position, turn the pencil 90 degrees to the left (at right angles to your first measurement). You can then see how many times the distance you have measured will fit into the length of the body and so judge whether you have the head about the right size.

You can compare the width of the head with its length in this way, or the depth of a body with how long a leg is – anything that will help to relate one part to another.

It can be so infuriating to put a lot of work into one area of a drawing, then to stand back to look at it and find it doesn't work as a whole, so it is useful to try and get a broad view of what you are doing down on paper before trying to put in too much detail.

Using the methods we have discussed, you can see how points relate and discover how ears and paws, for example, compare in size. Often you will be surprised by what you discover. We all have a tendency to put down on paper what we expect to see rather than what is actually there. We seem to carry a mental image in our minds of what a tree should look like or an eye or an apple, and for most of the time this doesn't matter. However, when we are drawing, we have the time to look and to be delighted by what we see – the juxtaposition of one shape with another, the surprising proportion of one thing with another can give a jolt to our preconceived ideas and help produce something new and exciting.

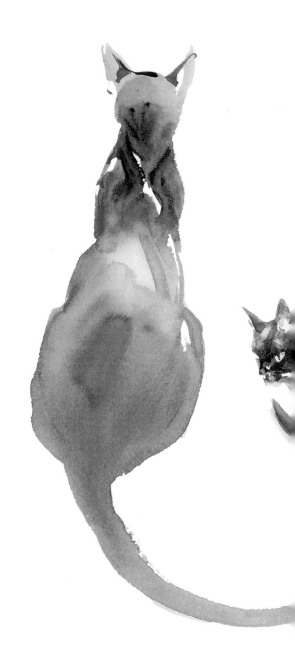

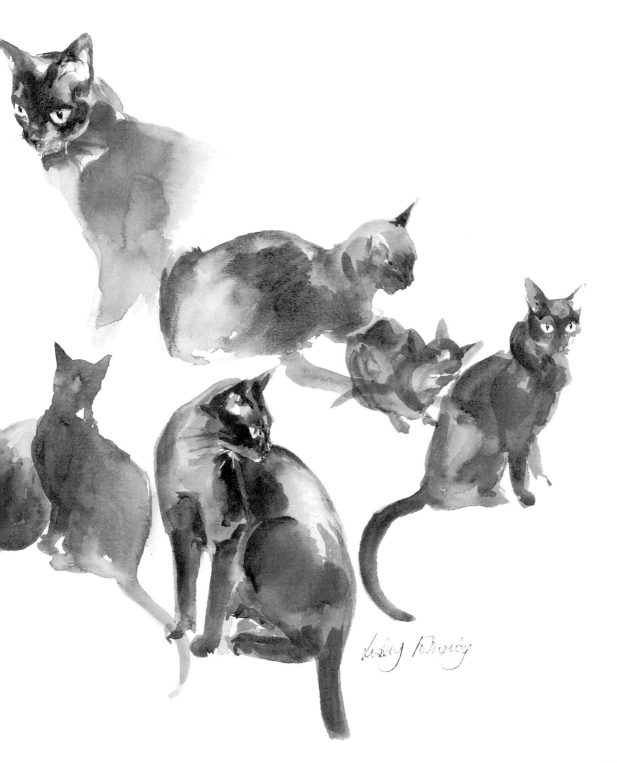

Once you have started to draw, and feel comfortable using pencil and paper, you will want to experiment by using different drawing tools and different papers. Pencils, pens and charcoal all have their own particular qualities, and these in themselves will change the drawing you do, allowing you perhaps to concentrate on line or on solid areas of tone. What these

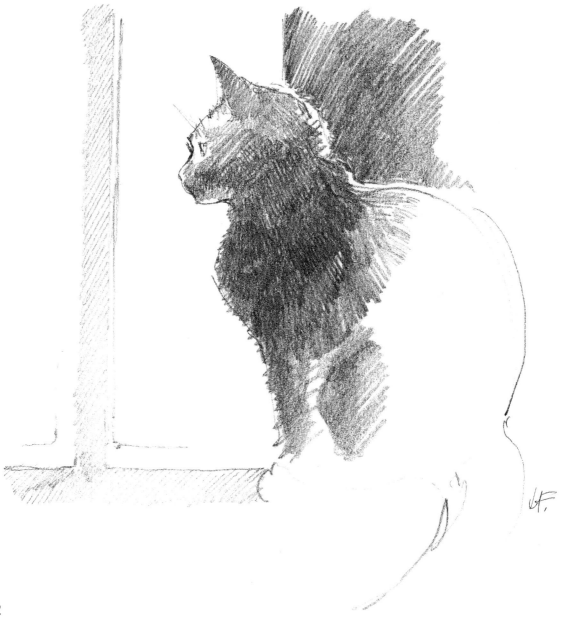

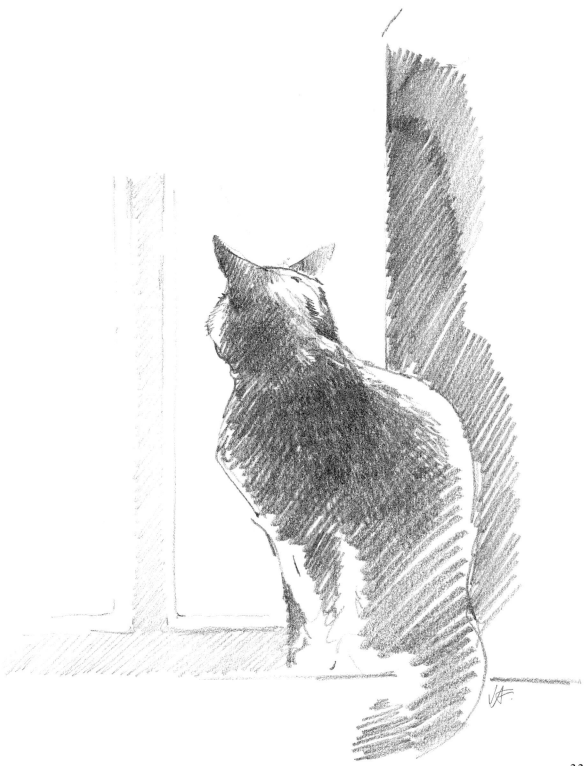

tools can do will be modified again by the type of paper you use them on. The combinations are endless.

A black cat sitting on a window ledge and peeping out from behind a curtain presents a very strong image (see pp. 32, 33). Most of the detail on the cat is lost because of the strong light behind it, and we are aware of the silhouette. We are also very conscious of the shape created by the light windowpane, which has been cut into by part of the cat. These drawings were done when I was sketching Rascal, a friend's cat, and he jumped on to the window ledge to see what was happening outside. They are two of series of quick sketches and it was fortuitous that he sat so obligingly.

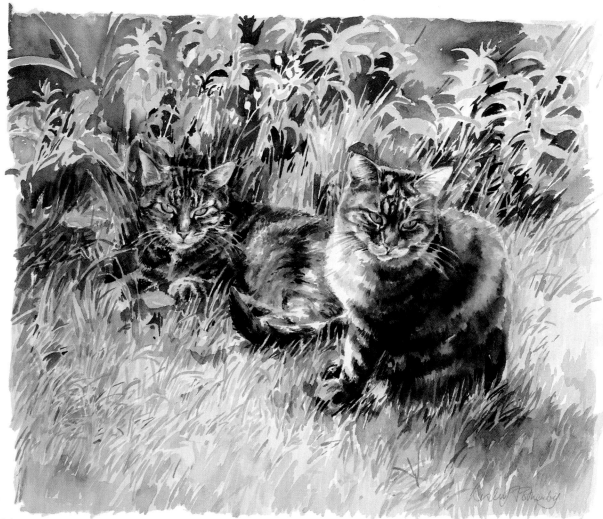

If you can get your cat to sit like this for you, that's marvellous and you can try a drawing for yourself. But it is not usual for a cat to be so co-operative, so you could try these exercises in looking at negative shapes and be prepared for when something similar occurs.

1 I have used a jug, a vase and a plant (some flowers will do) in front of a window. Don't put them in a straight line. You want to look through the plant at the other things you have chosen. Now draw the shapes between the objects. Don't draw the lines where they overlap – just the shapes on the window. By drawing these negative shapes you will build up a positive picture.

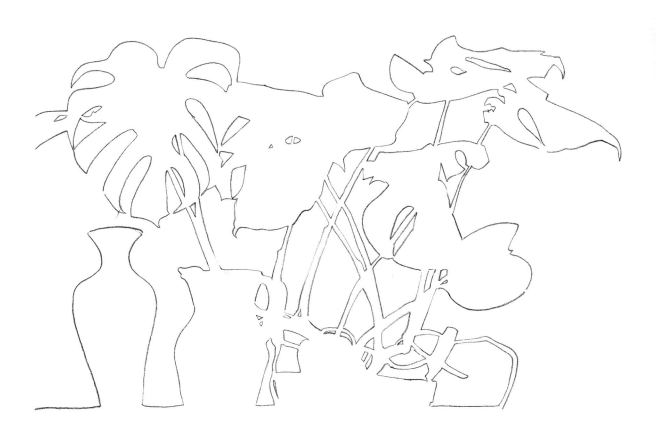

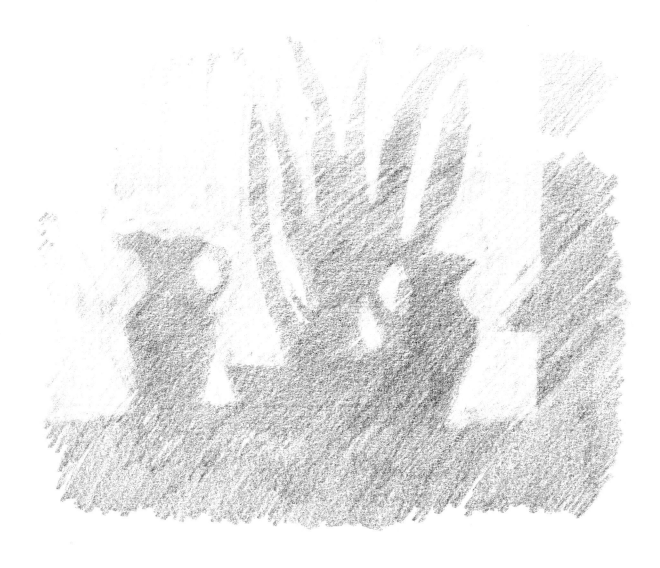

2 Set up a similar still-life. Then, with a soft pencil, shade in the whole of a piece of cartridge paper. Take an eraser (a plastic one is good for this) and rub out all the light shapes which the objects have created as they cut across the window. Again you will see the positive picture emerge.

Exercises such as these force us to approach a drawing in a different way. We have to forget about what we expect to see and really look at what is

there. They also help us to make judgements as we are drawing. If, for example, we are aware of what the space looks like between the front and back legs of a cat, we are more likely to get them correctly positioned than if we merely think of the shapes of the legs – after all, this way we have twice as much information.

Tone and Shading

Starting to draw is rather like learning to drive a car – there are so many things to think of and to do all at the same time. Drawing is not fraught with the physical dangers of driving, but there is a comparison in that you have many different things to consider simultaneously when you start. In previous pages we have gone through a few exercises which help you to judge proportions and to look at what you are drawing in a new way – to see how one object or part of an object relates to other parts and so creates new shapes we may not initially have been aware of.

Of course we see things not only as shapes but we also see them in three dimensions – up and down, side to side and front to back. The way light falls on an object 'describes' its shape or form, so we need to use a range of tones from black to white when we are drawing. I have briefly explained what is meant by the word 'tone' in the section on drawing materials: tone is how light or dark an object appears to be regardless of its colour. If, for example, you took a black-and-white photograph of both a green jug and a red jug, as long as the depth of colour of the jugs was about the same, the photographs would be identical because you would be aware of how the light was falling on the contours of the jug and that would be the same for both jugs regardless of their colour. (I have chosen a jug for you to study because the shape is similar to the body of a cat.)

When I was at school, we were taught about tone by copying a colour reproduction of a painting using only black, grey and white. If you have the time and the inclination, this is a very effective exercise to try.

One way of being able to perceive more easily the tonal values is to half-close your eyes when you are looking at your subject. You are then more

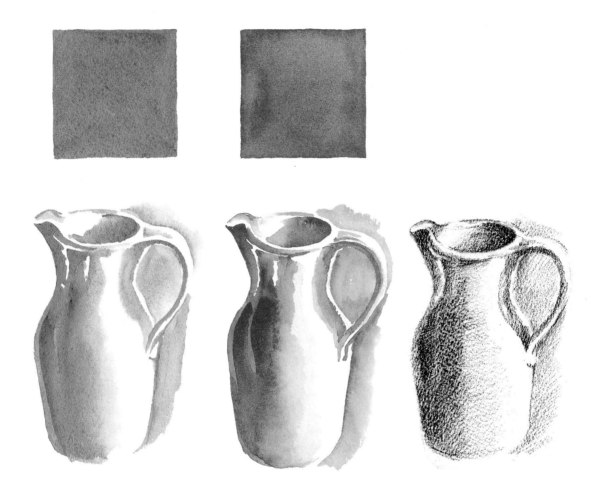

aware of how light and dark certain parts of the object are because you are less conscious of colour. If we eliminate light in this way, our eyes are less able to distinguish colours, but more able to see light and shade.

The drawing opposite is of two grey cats, but, as you can see, the colour doesn't matter. What is important is how the light hits their bodies and shows their form. The cats were asleep on a chair in front of a window, so they are lit from behind and above. See what strange tricks this lighting plays with the top cat's ears, for example: the right ear is very dark and is

an almost solid black shape against the left ear, which is in full sunlight. Surprising effects like this make a drawing interesting because they are not what we expect to see.

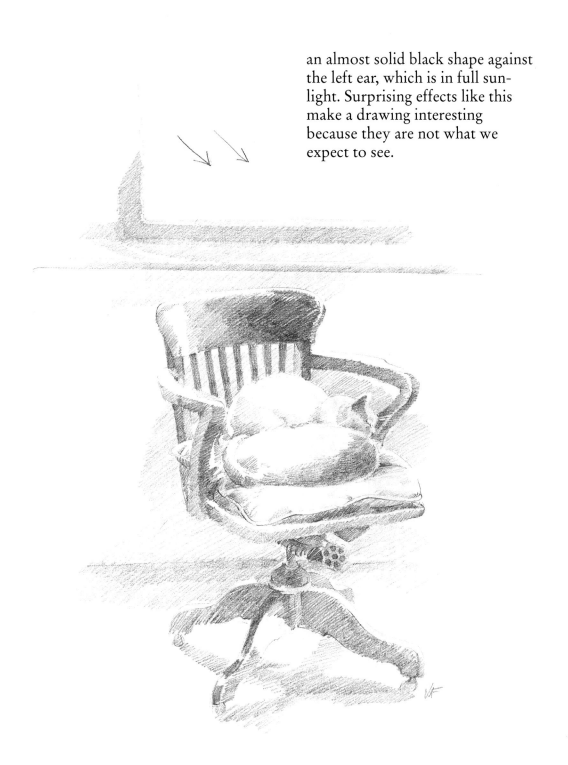

Try a drawing of your cat while it is asleep in a well-lit position. (This shouldn't be too difficult as cats seek out sunny spots.) If you have a tabby or a tortoiseshell cat, try to ignore the patterning because at this stage we are only interested in how the light shows us the form of the cat. I will deal with markings later on.

Put in the minimum amount of line drawing – only enough to give you a guide to the shape – and draw these lines in lightly; then concentrate on shading in the darkest areas, gradually getting lighter and leaving some white areas of paper where the sun is fully illuminating the cat.

Of course, leaving white paper to show light is all very well, but you only achieve a dramatic effect in a drawing of this kind when you see white against another tone. If I had left the ear of the cat in the drawing unshaded

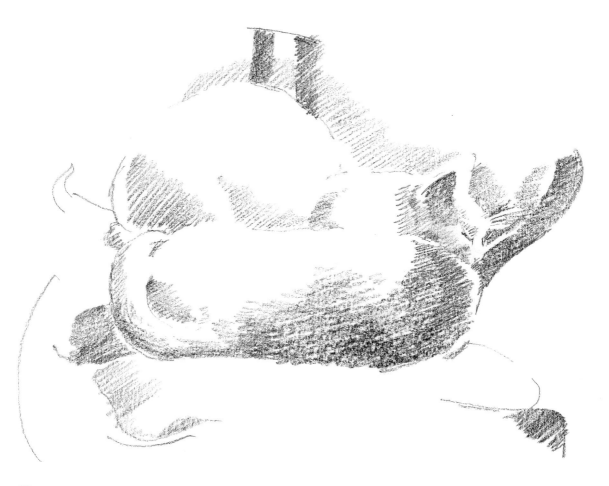

with just a line round it when I had used dark tones elsewhere, there would have been no sense of the solidity of the top cat or of how strongly she was lit. So I have looked beyond her to the background, which is a middle tone. This shaded area contrasts with the white highlights on her back and 'throws' the cat 'forward', towards us. In this way the depth of the picture has been increased.

As your drawing progresses, you will see the lines you first drew disappear or at any rate become much less dominant. You become aware of solid blocks of tone, one butting on to the next.

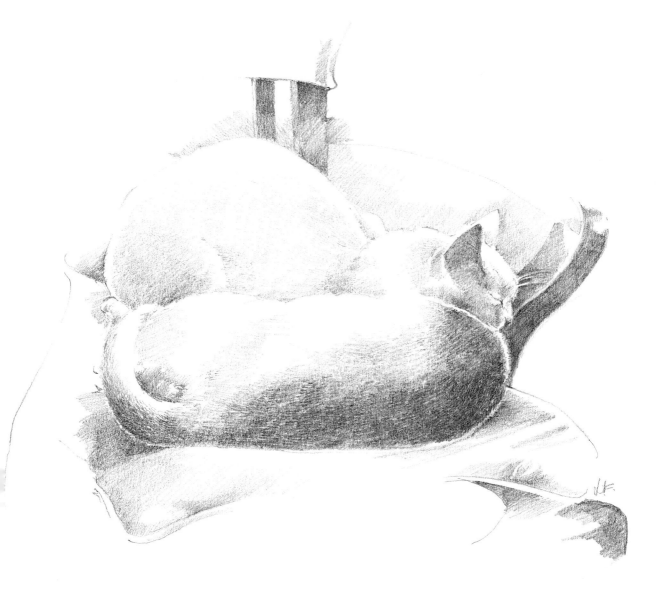

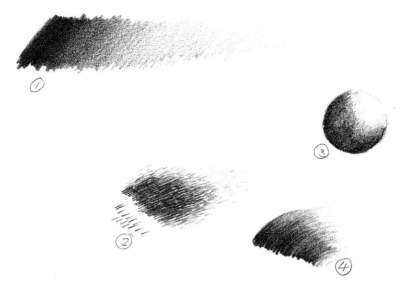

Shading

You can shade from dark to light with a pencil by increasing or decreasing the pressure of the pencil on the paper. We are aware of the lines the pencil makes (I have worked my pencil in the direction of the fur to give some indication of texture), but not as much as with pen and ink.

The more pressure you put on your pencil (I have used a 5B) the darker the shading. On the top left (1) I have drawn consistent diagonal lines – the only variation from one side to the other is the amount of pressure I have put on the pencil as it travels over the paper.

The next shaded area (2) is built up using broken, overlapping lines, again of different intensity. This gives a more textured appearance to the shading, like fur.

In (3) and (4) I have used the direction of my pencil lines to indicate the shape of the object I am shading; it is as if my pencil is feeling its way around the sphere and the curve.

If you think, while you are working, of the form you are drawing and how it would feel if you passed your hand over it, this will help you to move your pencil in the direction your hand would go and so achieve a feeling of solidity. Your eye will follow the marks which lead you over the sphere, curve or cat.

The blocks of shading below were done using the same pencil in exactly the same way as the first set but on different, more textured paper. See how this change of paper alters the effects you can achieve.

Try shading on as many different types of paper as you can find.

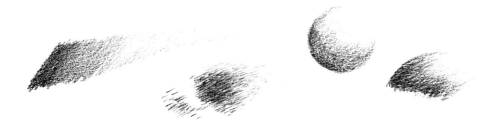

If you want to use pen and ink instead of pencil, then the same rules apply, but the technique is slightly different. To achieve a darker tone with pen and ink, we have to see less of the paper between the pen strokes. To make an area lighter, more paper has to show, so the lines may be broken or further apart.

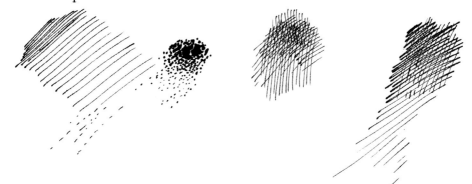

In the first block of shading above I have used parallel diagonal lines; the closer together the lines are, the darker the shading appears to be. The same applies to the dots: the closer they are together, the darker and more solid the area appears. (If you look closely at black-and-white newspaper photographs, you will see this is the printing method used.) The other two examples are of cross-hatched lines; the more the lines overlap, the darker the area they build up.

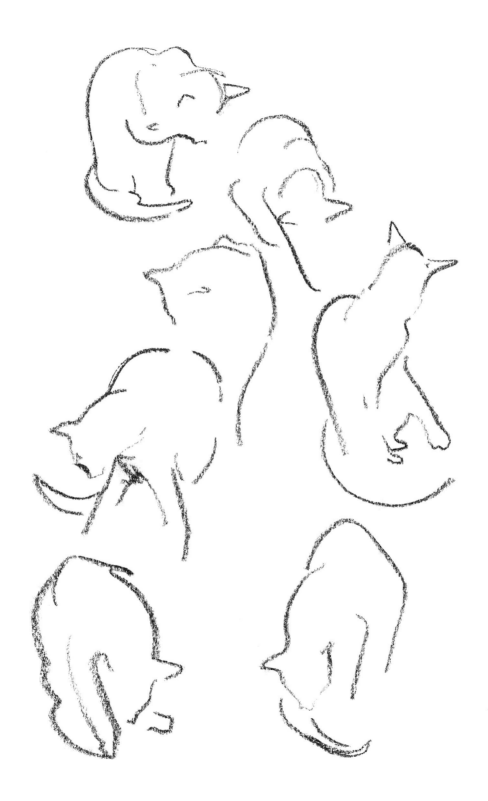

Movement

Cats sitting or lying relaxed achieve wonderful positions and, as we have seen, it is best to start drawing them when they are still. However, as you begin to gain confidence, you will want to draw your cat in more complicated poses and to make sketches as the cat is moving.

Don't start with anything too spectacular like a leap across the room, but observe your cat washing, for example. The cat will stay in the same place, but perform a series of movements, often repeated, which will allow you to look several times at each position as it is taken up.

The drawings opposite were done of one of our cats, Perdi, as she was washing. I used conté crayon on a 'not' surface watercolour paper and, as you can see, I have used line only. There is very little detail – no eyes, in some instances no paws and in several of the sketches just one line for the tail. I had to work quickly and so I only concentrated on the essentials.

In the first drawing Perdi is washing her face. While she does this, her body stays relatively still – the head moves up and down to lick the paw, and the foreleg and paw move around the head and right ear. I chose one instance in this set of movements: the one when the paw was at her mouth being licked. I decided on this before starting the drawing so that I could check on her position each time she resumed that particular pose.

One way of picking out and retaining in your mind an instance in a movement is to look at your subject, then suddenly close your eyes so that the eyelids act like the shutter of a camera freezing that moment. With your eyes still shut, move your head downwards; and now open your eyes so that you are looking at the drawing paper and immediately draw as much as you can remember.

I said above that I had concentrated on essentials because I was working quickly. The first and most important line I put down was the line of the cat's back, which is curved, and the hump of her shoulder, then I drew a semi-circle for her head and put in her ears. As I left out every other feature of her head, you may wonder why I have put ears on all the drawings. I have done this for a number of reasons. Firstly they give a pointer to the object of the cat's interest, i.e. which direction she is looking in and

thus moving towards. Secondly, ears tell us what position the head is in – we know she is looking down because her ears stick out sideways from the curve of her head and her face is then obviously tucked away underneath. Thirdly and most importantly, the shape of the ears indicates the type of animal more immediately than any other feature I could have put in.

Once I had the curve of the back and the head drawn in, I sketched in the right foreleg (the one which was moving) in the position I had decided upon; then I drew the left foreleg and the tail, both of which were still. Although it is the head and the right foreleg which are moving, the left foreleg is very important in this pose: all the weight of the front of the cat is resting on this leg – you can see how it follows up in a straight line to the hump of the shoulder blade. Because of this, the drawing contains a contrast of tension and relaxation.

The rest of the sketches continue to catalogue the process of washing. In each drawing I have started with the line of the back, the head and the ears.

When you try this, I suggest you use a drawing medium like conté, charcoal or pastel. All of these will give you a broad, free line. Don't try to put in a lot of detail. It doesn't matter if the cat has no eyes or only one line for a leg – our brains will fill in the missing information as we look at the drawings.

The Structure of a Cat

Cats are capable of great speed and agility, and also of extreme stillness and control. If you have watched cats hunting, you will have seen how they can stop part way through a movement and stay frozen in a pose until they are ready to strike. They have a very high degree of muscle control.

Their backbones are extremely flexible – merely in washing and sleeping cats can bend and stretch their bodies into wonderful contortions – and it is in order to help make sense of these poses that I suggest you draw an imaginary line from the centre of the head, continuing along the spine and down to the tail in the direction you would stroke your cat. (We used this line earlier – see p. 27.)

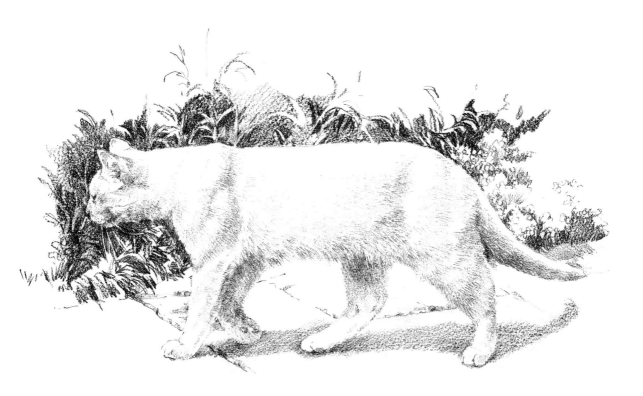

If you look at a cat from the side, this line I have described will form the top of its silhouette.

If you stroke your cat along this line, you will feel, as your hand passes over the neck and on to the body, two humps which are the shoulder blades.

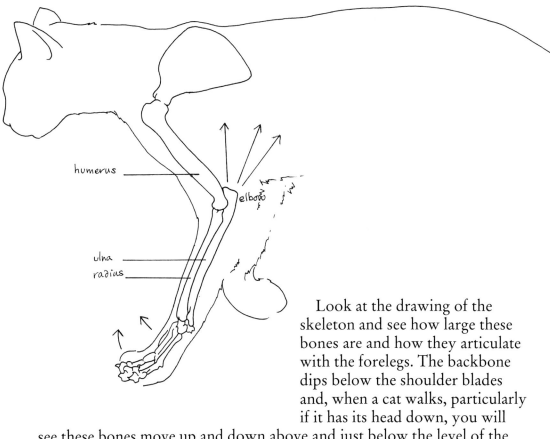

humerus

elbow

ulna

radius

Look at the drawing of the skeleton and see how large these bones are and how they articulate with the forelegs. The backbone dips below the shoulder blades and, when a cat walks, particularly if it has its head down, you will see these bones move up and down above and just below the level of the spine. So, when you are drawing the forelegs of a cat, remember that the line of the legs follows on right through the body and up to these powerful shoulders.

You will also see from the skeleton that cats walk on their toes, on what would be the ball of our foot. This allows them a long stride and means they can move swiftly because only a small part of the foot is touching the ground.

The rear limbs are long and powerful. They can pull the back of the cat down in preparation for a jump, when they will propel the cat forward, or, when stretched, they can lift the back of the cat. Again, remember the legs are not just stuck on at the point at which we see them disappearing into the body – they continue right through the body to the pelvis and spine.

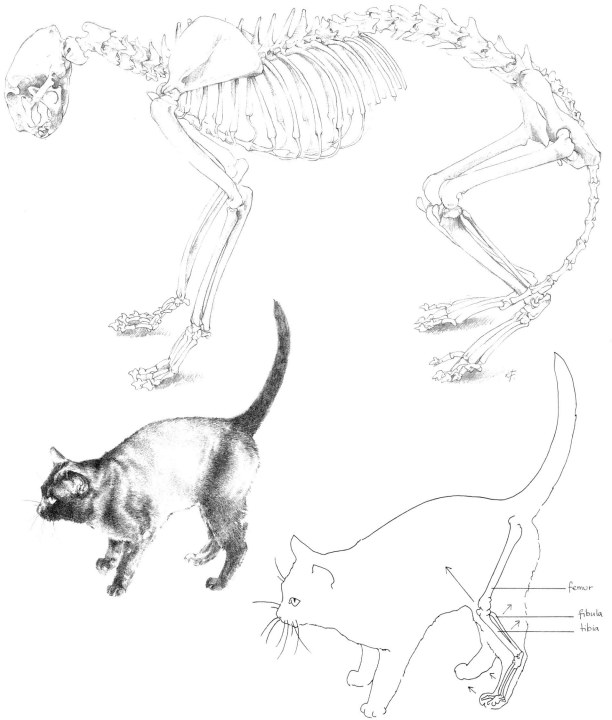

femur

fibula
tibia

49

Heads

The shape of the head and its proportions vary from cat to cat. There is a striking contrast between the face of a Siamese and that of a Persian, for example. The length of the nose is different, as are the shape of the eyes and the size of the ears. All non-pedigree

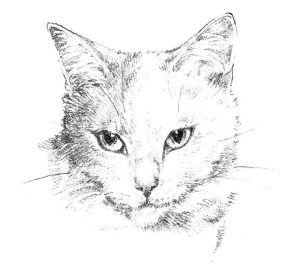

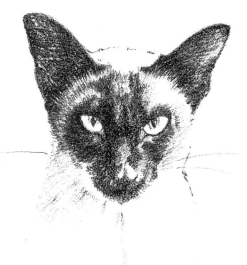

our face one side of that line is pretty much the mirror image of the other half. The same is true of a cat and in the first drawing on the opposite page you will see the line of symmetry running down the

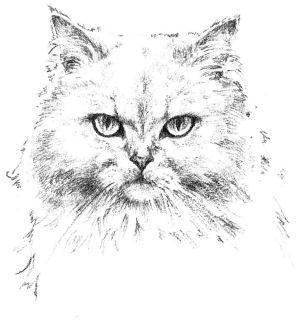

cats will differ slightly, too, but of course there are many common characteristics which we can look at – they will help us in observing and drawing.

When we look at ourselves in a mirror, we are aware of the symmetry of our faces. If we were to draw a line down the centre of the forehead to the chin, the part of

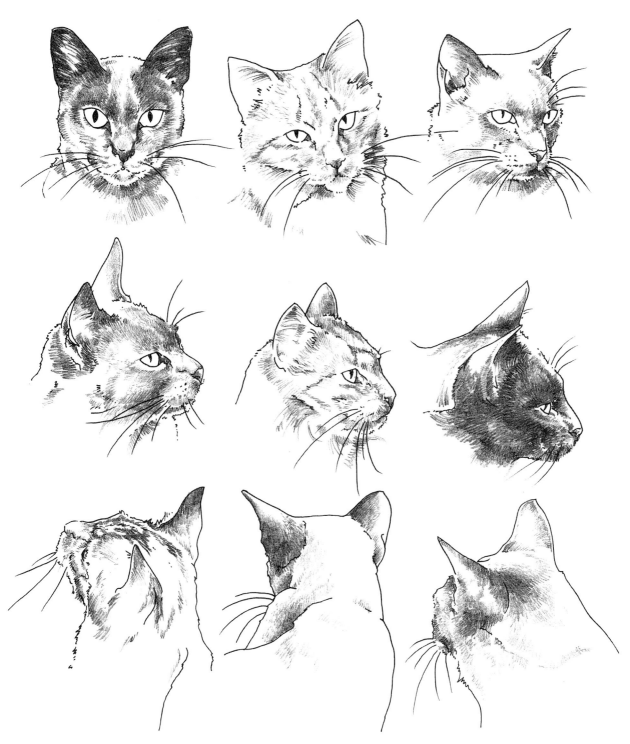

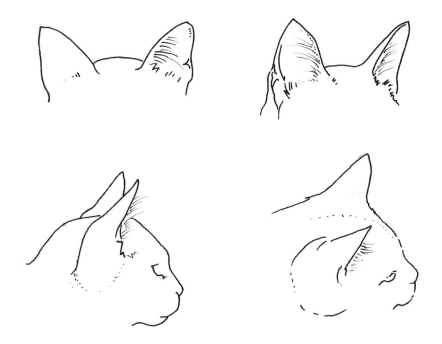

middle of the cat's face. At right angles to this is a line to give the approximate position of the eyes – this is about half-way down the face. I say 'about' because this position can vary slightly from animal to animal. (Look at the Persian cat on p. 50, below right – his eyes are just below that half-way mark.) You can check the position of your cat's eyes by holding out a pencil at arm's length in front of the animal and measuring on it with your thumb the top half of the face as compared with the bottom half (see p. 28).

The diagonal lines (p. 51) indicate the wedge shape of the lower face. Stroke your cat along these lines and you will feel the cheek bones protruding diagonally upwards under the eyes.

The two outside lines which are parallel to the line of symmetry help to place the ears. Notice that the bottom of the ears start on the forehead, so don't be tempted to treat them as an afterthought and just pop them on the top of the head. You will be able to place them by following the line which runs from just above the eye upwards and outwards over the forehead. (This line is created by the fur growing in two different directions.)

Let us now go back to the first line – the line of symmetry – and see how this changes as the cat moves its head around and into profile. (If we extend this line, we can recognize it as the one we have already drawn along the backbone and the tail.) As the line moves to the right, we see more of the left-hand side of the face and less of the right. The shape of the eyes changes and so do the ears (see p. 51).

When the cat is in full profile, we can see that the distance between the tip of the nose and the chin is quite considerable – about the same as from the tip of the nose to the eye. It is longer than you might think from looking at the cat full face.

Another measurement to note is the distance between the front of the forehead and the back of the head. (Look at the centre row of drawings on pp. 51 and 54.) It is a common mistake when drawing animals and people to underestimate how much of the head is at the back.

Try some drawings of your cat's head using either a pen or a pencil. Don't put in any shading. Look particularly at the proportions and how one feature relates to another.

When you want to give some form to your drawings and to use shading, either with pencil or pastel, it is helpful to look at how the fur grows on the cat's face. If you shade in the direction of the fur, you will more easily achieve a solid form and be able to make sense of where shadows occur.

Stroke your cat's face again – there is a complex set of directions to the fur. As you will see from the diagram, it grows outwards, away from the eyes and mouth. Above the eyes the directions vary slightly, the dividing line being between the inside of the eye and the start of the ears. Below the eye the fur

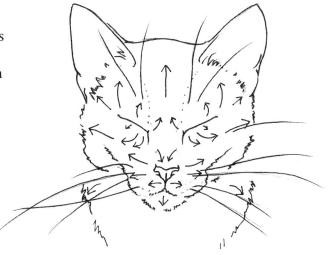

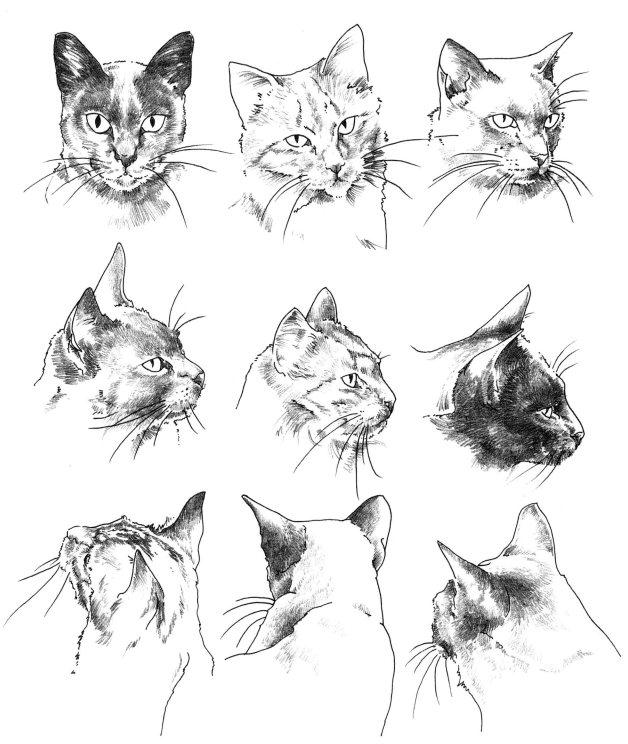

grows outwards and downwards, which gives us an indication of the structure of the face and how we might show it. The eyes are set back in the head for protection, so the cheekbones will protrude below them; this is where the fur is growing outwards. It then curves out and round the cheekbone, and grows longer toward the side of the head. The top of the cheekbones will be lighter, below will be darker, lightening again where the fur grows out at the side of the head.

The fur on the nose is very short and grows in two different directions, giving a faint curved line about half way up the nose.

Below the nose the fur grows outwards, across the muzzle and down the chin. You will find that the area just below the nose is usually in shade; the part of the muscle which curves outwards is lighter and, as it disappears backwards, so it will become darker again.

Light and shadow on any object will vary according to the source of the light, so I have given a very approximate indication of where the dark and light parts of the head will be.

Any part which protrudes, like the forehead, the bottom part of the nose, the cheekbones, muzzle and chin are more likely to catch the light than areas which are set back, i.e. the eye sockets, the area between the eyes, under the cheekbones and beneath the chin.

Remember what we noticed in the drawing of the cats on the chair. However, general rules like these can be modified by circumstance, so always *look* carefully. When the light plays tricks, you will have an especially exciting drawing.

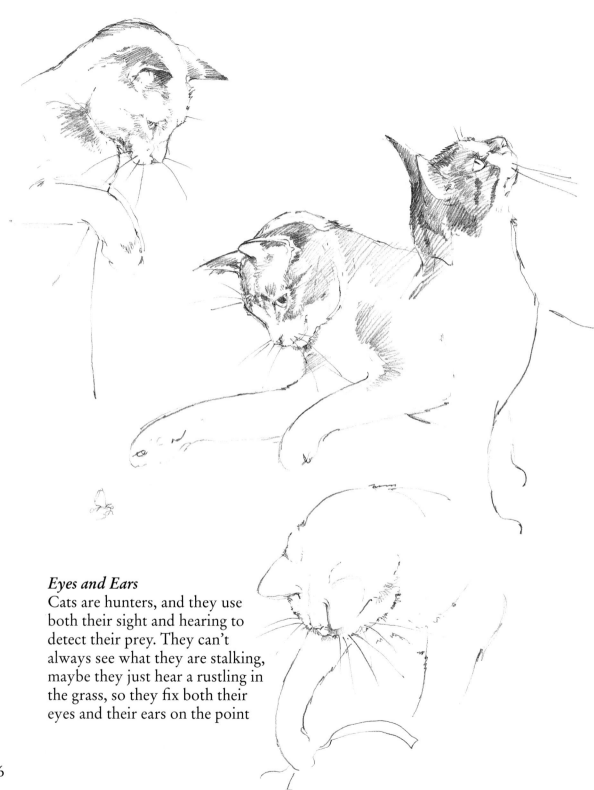

Eyes and Ears
Cats are hunters, and they use
both their sight and hearing to
detect their prey. They can't
always see what they are stalking,
maybe they just hear a rustling in
the grass, so they fix both their
eyes and their ears on the point

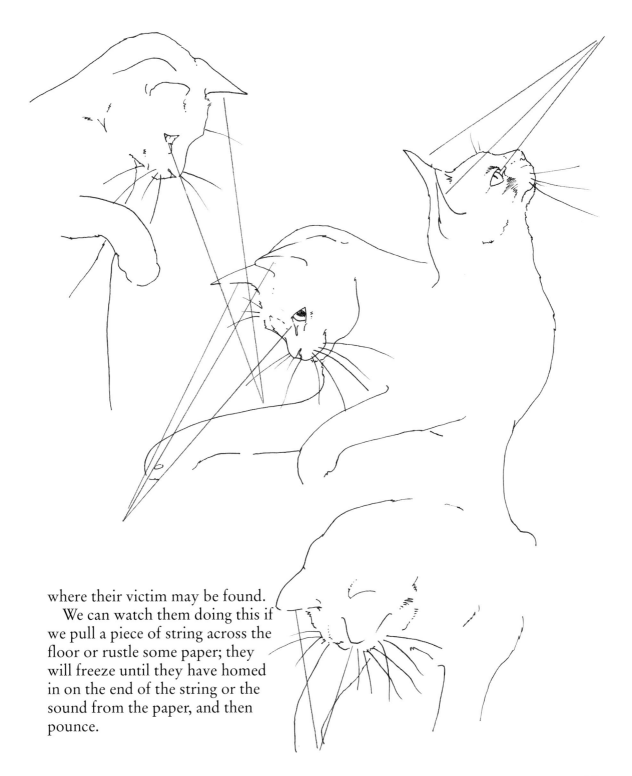

where their victim may be found.

We can watch them doing this if we pull a piece of string across the floor or rustle some paper; they will freeze until they have homed in on the end of the string or the sound from the paper, and then pounce.

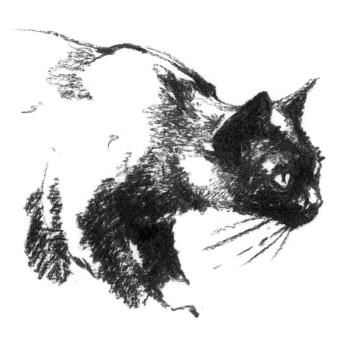

A drawing of a cat hunting or playing will be more convincing if the eyes and the insides of the ears are pointing in the same direction.

Eyes

If we view a cat's eyes from the front, we see that they are almond shaped, sometimes opening almost to a circle. The iris occupies most of the area of the eye visible to us, and the pupil is a vertical slit in its centre. The pupil dilates and contracts depending on how much light the eye requires. In bright sunlight it will be a narrow slit; in the dark or when a cat is concentrating on its prey (or if it is angry or excited), it can open to a circle.

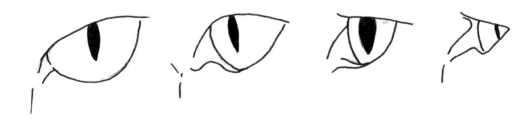

As the cat moves into profile, so the shape of the eye changes: the width of the almond becomes less and less until it reaches a triangular shape. In full profile you will see that, behind the curved cornea and the transparent fluid of the aqueous humour, the iris and the pupil occupy a flat plane. Sometimes, as the cat is turning away from you, this transparent area gives the illusion of the eye disappearing altogether.

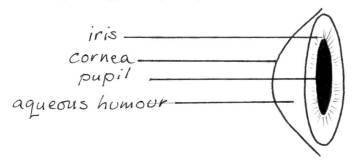

Ears

Seen from the front, the ears are triangular in shape and set at a slightly outward angle. Inside there are long hairs growing towards the outer side of the ear. As the cat turns sideways, it becomes evident that the back of the ear is curved. If you cut a piece of paper in this shape

and then bend it slightly, you will gain an idea of the shape of the ear. Points A and B will be at the front of the head, the curved section at the back and side.

Markings

Tabbies and tortoiseshells are particularly beautiful cats. Tabby cats often have symmetrical markings on their backs and heads, and very intricate designs of stripes on their chests and legs. The patterns on tortoiseshells are rather more haphazard.

When drawing them, it is easy to be so engrossed in following these patterns that we forget about the basic structure of the cat. Structure is crucial because it determines the shapes made by the stripes.

On a piece of A4 (approx. 21 cm x 30 cm) paper paint some parallel stripes. If you use lined paper, this will make the task quicker and the stripes don't have to be too precise. Roll the paper into a tube and fix it with adhesive tape. Now lay this tube in front of you at different angles and make some drawings of the stripes. See what shapes they make as they follow the contours of what is now a three-dimensional form.

Always consider what your cat would look like without its patterning.

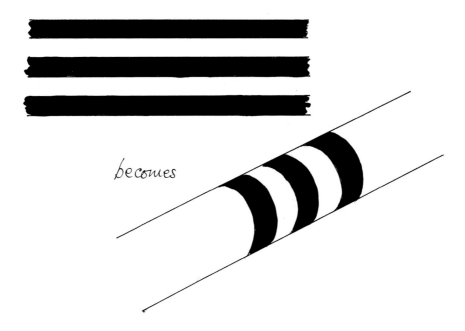

becomes

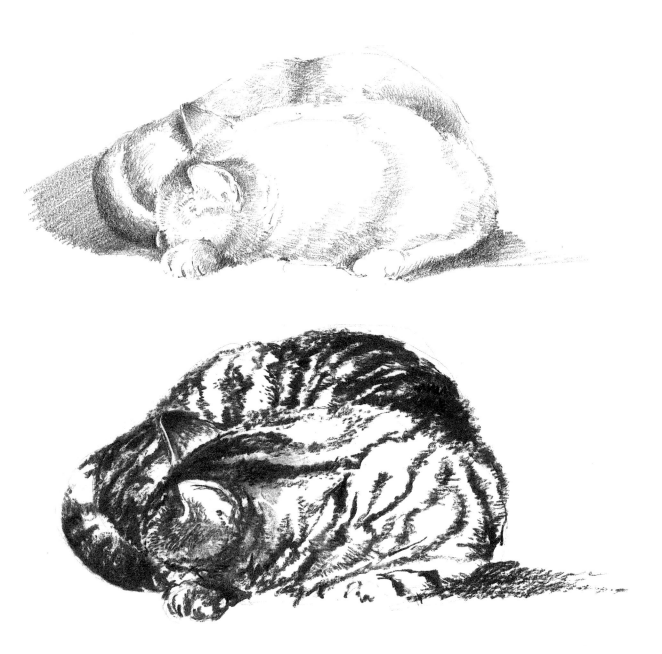

These drawings are of the same cat, but, as you can see, I have left out
the markings in the first sketch. When the stripes are put in, you can see
how they follow the curve of the body; in fact they emphasize the contours
of the cat and make it easier for us to see how his body is curled. It is

important, therefore, to see the two elements – pattern and form – in conjunction. You can't paint the front door of a house before you have built the house and similarly you must have a solid cat before you consider what patterns are on its surface.

When you put in these patterns, you will see how they give you additional help in achieving the form of the cat. As with the stripes on the tube of paper, they can, on their own, describe the shape. Look back to the diagram on page 62. The bottom set of stripes are painted between two parallel lines; there is no shading and I haven't put in any other lines to show that these are part of a tube, but we know that they are because the shape which the stripes make tells us so.

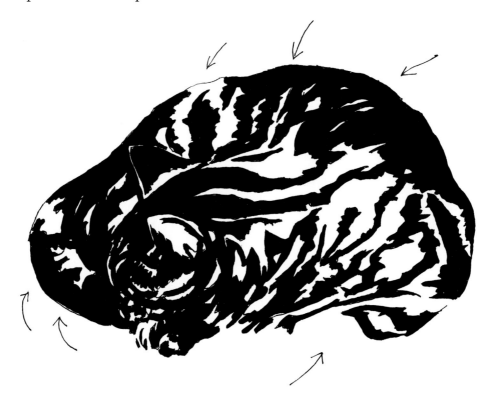

This drawing is of the same cat as before in the same position, but I have emphasized the stripes and omitted the shading. Look at how much the direction and curve of the stripes tells us about its form and how it is lying.

If you have a cat with markings, make a drawing of it asleep, preferably curled up. Use a soft pencil and first make a rough sketch of the outline and where the shadows are. Then you can really enjoy yourself and, pressing more heavily on the pencil to achieve a darker tone, put in the patterning.

If your cat is just one colour, make a sketch with some shading and then, looking at how the cat is positioned, draw in a series of contour lines (like those on a map) over your drawing. You can imagine the line down the centre of the back and parallel lines round the body and tail (as on the tube). What would these look like as they follow the curled shape of your cat?

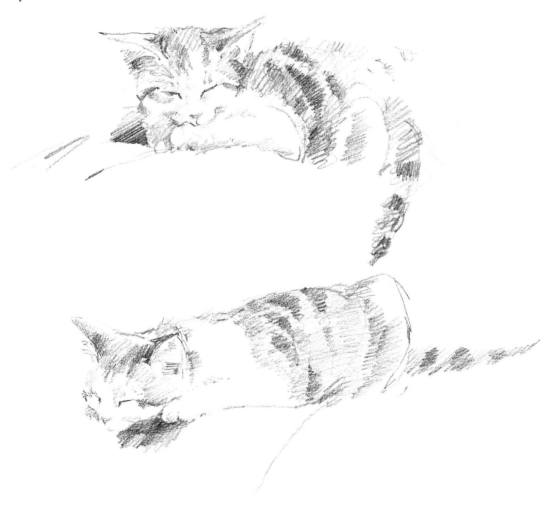

Watercolour

What Is It?

By now you will have spent some time looking closely at cats, noting their proportions, watching how they move and, by observing and stroking them, getting to know more of their structure. All this will have helped you, I hope, to be able to capture something of your cat on paper and to feel more confident about representing what you see. This confidence will enable you to explore other means of expression and in this section we shall consider watercolour.

Watercolour is a transparent medium which allows the white paper to shine through the paint and for you to build up layers of colour. Each colour put down on the paper will affect other colours painted over it. Think of layers of tissue paper – if you put a red sheet down and then cover it with a yellow sheet, the red will show through the yellow and make it look orange.

Because it is a transparent medium, the amount of water used with the paint pigment determines

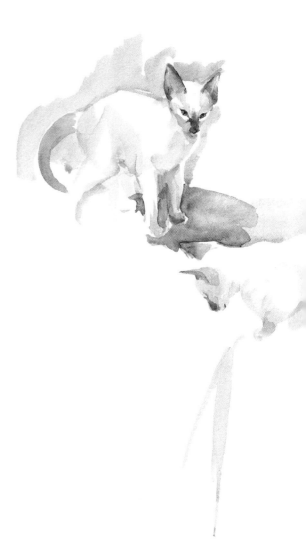

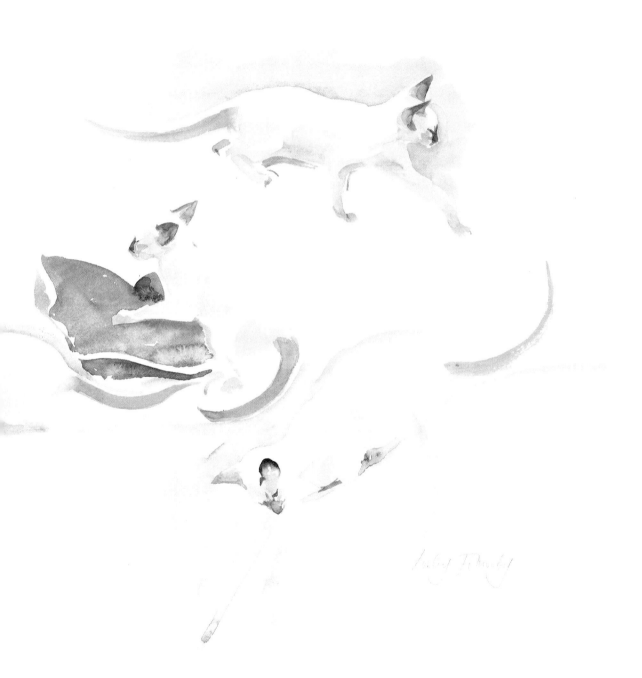

the intensity of the colour – more water and the colour is pale; less water and it becomes more intense. Consequently white is *not* used to achieve a pale hue as it is in an opaque medium like oil paint or gouache.

The quick-drying quality of the paint makes it ideal for putting information down on to paper swiftly. I like to use it directly, without drawing in pencil first, because I then don't feel restricted by having to follow a line, and the sketching process is speeded up by not having to switch from pencil to paint. However, this is my particular preference; other artists sketch briefly before laying down colour and, if you like to do so, that is fine – just don't feel too restricted by the initial lines you have drawn.

Before we get down to basics and look at the materials you need for watercolour painting, on the previous page are some examples of watercolour sketches to show you what I mean. When painting these, I was helped by the coloured markings on the ears, tail, nose and paws of the Siamese kitten. It meant I could use a kind of shorthand and not bother with much detail on the body – the coloured markings give enough information for our brains to fill in the gaps and make sense of the picture.

Sometimes, if I am making a series of sketches, I do watercolour and pencil work on the same sheet. This forces me to look at the cat in a different way, depending on which material I am using: the bulk and colour with the paint, and the fluid outline with the pencil or crayon.

The three sheets on pages 70–71 are from a series of sketches I did of four cats in preparation for a painting. The first sheet, at the top of page 70, contains colour studies of two of the cats and a line drawing using a 6B pencil. The sheet below is also a mixture of watercolour and pencil; I made a painting of one of the cats, Dillon, using Raw Umber, Sepia and Ultramarine, and then added quick colour notes of the tortoiseshell cat. Using a 6B pencil again, I have sketched the two cats together and made a note of the rather unusual shape of Dillon's ears.

I have used black conté with the colour sketches on page 71. The line drawings in the centre were done very speedily because I wanted to catch the relationship of the two cats to each other and I knew they would not keep the pose for long.

I hope you will see from these three sketches how many of the things we considered in the drawing section apply equally when painting. But let us now look at the new element – colour.

Choosing Your Materials

Paint

Watercolour paints are available in two forms: as solid blocks called 'pans' and 'half pans' (according to size) or in tubes. The difference between the paint contained in them is that there is slightly more gum Arabic, which is the binder for the watercolour pigment, in the tubes than in the pans.

Boxes of half pans – the size most usually available – have the advantage of being easily transportable, but it takes rather longer to mix a large amount of a colour than it does if you are using tubes.

I started watercolour painting when I was given a large box of students' watercolours and I learnt how to use them by trial and error. I do think, however, that the Artists' Quality paint is well worth buying, even if you are just a beginner. Because of the quality of the paint, the vibrancy of the colours will make your results more encouraging and, as you will see in the basic palette, you don't need to start off with a vast array of colours.

Of course, once you begin, you can add different colours to your basic ones as tubes and half pans can be bought separately. I find a display of tubes of paint irresistible and I always think that a new colour discovery will transform my painting! The price of colours varies according to which pigment you buy: series 1 are the cheapest, and series 5 the most expensive. I nearly fainted when I first bought a half-pan of Vermilion, but, having said that, watercolours last a long time and it is an economical medium to use.

If I am working indoors and don't have to move around too much while I'm in the process of painting (i.e. if I'm not having to crawl about the floor after a cat), I use white plates to mix my paint on. White plastic palettes with indentations in which to mix your colours are lighter and easy to carry around. Whichever you choose, have several, as you need plenty of space for mixing.

Always use something white as a palette, then you will see the true colour of the paint as it will go on to your paper. Remember watercolour paint is transparent – metal or coloured palettes distort the colour.

Paper

Hand-made and machine-made papers are produced for water-colour painting, and most good art shops will have samples to show you of the different types available. The opportunities for experimenting are almost limitless.

I shall deal here with the machine-made papers, the best of which you will find described as 'mould-made'.

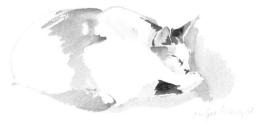

They have a rag content and are gelatine sized. All this information you will find on packs of watercolour paper or on watercolour pads together with a description of the surface quality of the paper and its weight.

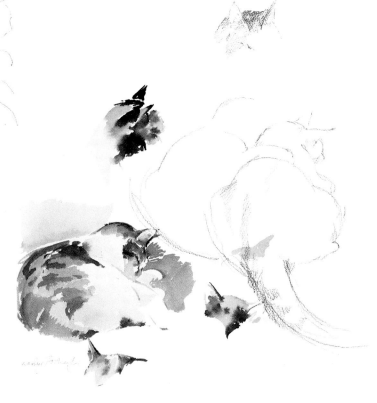

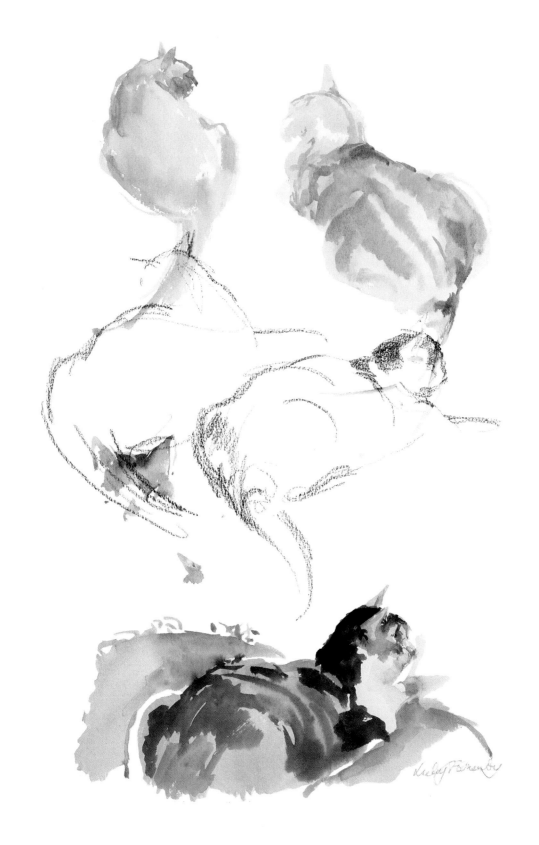

The paper surfaces are described as 'hot pressed' (HP or fine); 'not', which is 'cold pressed' (CP); or 'rough':

Hot Pressed: It has a smooth surface and is suitable for detailed work. Its main disadvantage is that it is more difficult to achieve an even wash of colour on hot-pressed than on cold-pressed paper because of its lack of grain. Hot-pressed paper is only available up to 140lb (300 gsm) weight.

Cold Pressed: This 'not' surface paper has the most versatile surface, it has a light grain and suits most types of painting. I recommend that you start with this paper for sketching in watercolour.

Rough: Such paper has a pronounced surface, which gives a broken wash of colour as the paint is trapped in the paper's indentations.

The most suitable surfaces for the work we shall be discussing here are hot-pressed paper and cold-pressed 'not' surface paper.

The weights of papers are expressed in pounds (weight per ream of 480 sheets) or in grams per square metre (gsm). There is some variation from manufacturer to manufacturer, but usually the weights are 90 lb (190 gsm), 140 lb (300 gsm), 260 lb (356 gsm), and 300 lb (658 gsm).

The lightest weight, 90 lb, is quite suitable for any sort of painting, but needs to be stretched before you start or it will cockle. (Thoroughly wet the paper with cold water before or after laying it flat on a wooden drawing-board, leave it for five minutes, smooth it out with a sponge to remove excess moisture, fix it down firmly all round with gummed paper tape, leave it horizontal until completely dry and then it's ready to use.)

140 lb is the most useful weight because it is easy to handle, fairly tough and easily available both in sheets (56 x 76 cm) and in sketch-books.

300 lb weight is the thickest paper, almost like a board. It is lovely to use and won't cockle, but it is expensive and this can be inhibiting when you are starting out. It is easier to put aside a painting which hasn't quite worked and to start on a fresh one if you aren't concerned about the price of the paper you are working on.

Watercolour papers are sized to reduce the absorbency of the paper and you will find them labelled as 'tub sized' or 'internally sized'. With 'tub sized' paper the sizing is done after paper production. With 'internally sized' paper, the size is introduced into the pulp. Tub sizing is the more

traditional method, but internal sizing also produces a consistent result.

The grain on papers varies from make to make, each manufacturer producing a slightly different texture. After a short while you will discover the ones which suit you best. If you buy your paper in sheets, rather than as sketch-books, you will see a watermark in the corner; when you can read this the right way round, that will indicate the right side of the paper, although you can quite well use both sides.

All good papers will be acid free.

Brushes

Sable brushes are the best and most versatile watercolour brushes. They have a good fine point, hold their shape well and are springy. Kolinsky sable are the finest quality.

Because the hairs taper to such a fine point and because of their flexibility, sable brushes allow you to use a large brush and still have enough control of the tip to paint fine lines. A large brush has the advantage of holding a greater reservoir of paint – therefore you won't constantly run out of colour, as you might with a smaller brush. This allows for greater freedom and fluidity.

Brushes which are a mixture of nylon and sable are probably the best substitute for pure sable, and they are more reasonably priced.

Also available are squirrel and ox-hair brushes. Squirrel wash brushes, which are large and dome shaped, make a very good alternative to the equivalent sable, especially if you are just starting. (The price of a sable wash brush can be very off-putting.) However, small brushes made of squirrel are rather difficult to control as the hair is much softer than sable. Ox-hair by comparison is stronger, but, although it is springy like sable, it doesn't achieve such a fine point and so it is often found in square-ended brushes, which can make useful additions for the distinctive marks they achieve.

Most series of brushes range in size from 000 to 14. I use a 6 or an 8 for the majority of my painting, even the most detailed, and I use a 1 or 2 less frequently for very fine work. I suggest you start with a No 6 because this will allow you to make bold strokes and get paint on to the paper quickly whilst still remaining manageable.

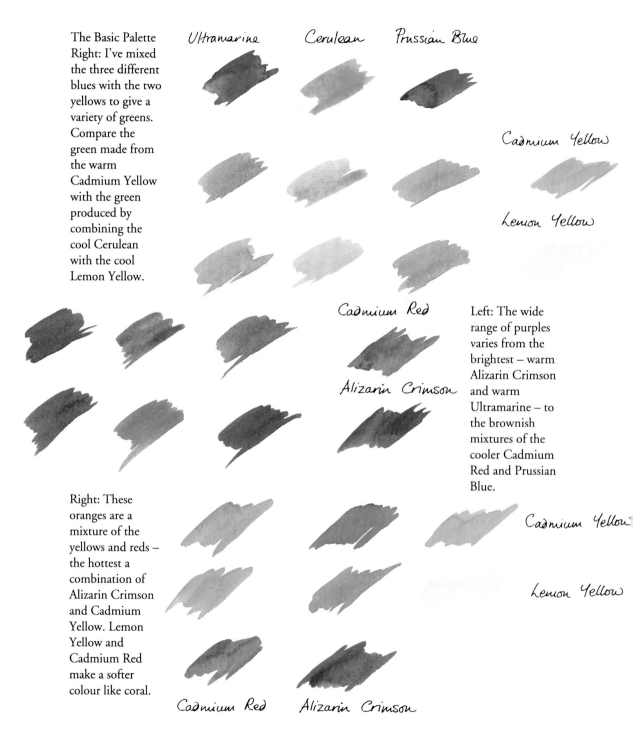

The Basic Palette
Right: I've mixed the three different blues with the two yellows to give a variety of greens. Compare the green made from the warm Cadmium Yellow with the green produced by combining the cool Cerulean with the cool Lemon Yellow.

Ultramarine *Cerulean* *Prussian Blue*

Cadmium Yellow

Lemon Yellow

Cadmium Red

Alizarin Crimson

Left: The wide range of purples varies from the brightest – warm Alizarin Crimson and warm Ultramarine – to the brownish mixtures of the cooler Cadmium Red and Prussian Blue.

Cadmium Yellow

Lemon Yellow

Right: These oranges are a mixture of the yellows and reds – the hottest a combination of Alizarin Crimson and Cadmium Yellow. Lemon Yellow and Cadmium Red make a softer colour like coral.

Cadmium Red *Alizarin Crimson*

74

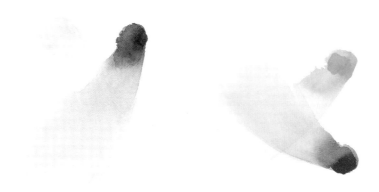

Colours can be mixed in your palette or on the paper. One transparent colour wash painted over another (when the first is dry) will modify both.

Above: Complementary colours

Below: The three primary colours mixed together make brown – these are just some of the variations.

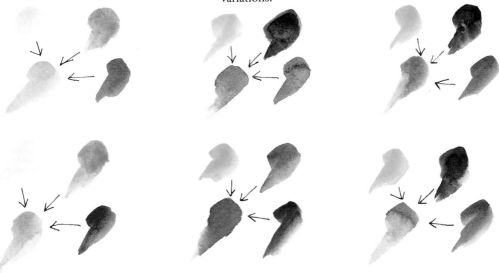

All About Colours

The Basic Palette

Almost every colour you will need can be mixed from a basic palette consisting of the primary colours – red, yellow and blue. You will see that there are two yellows and two reds – a cool and warm pigment of each; and that there are three blues – the warm Ultramarine and the cooler Cerulean and Prussian Blue. I have included two cool blues because of the different qualities of the two pigments: Cerulean is a clear, soft blue; Prussian Blue is much more intense and will give a greater depth of colour.

Yellows:
 Cadmium Yellow – warm
 Lemon Yellow – cool

Reds:
 Cadmium Red - warm
 Alizarin Crimson - cool

Blues:
 Ultramarine – warm
 Cerulean - cool
 Prussian Blue- cool

We tend to think simply of red as warm and blue as cold – fire and ice – but we can subdivide each of these colours and see how cool or warm the different pigments look in comparison to each other. If you look at Cerulean Blue compared to Ultramarine, you will see how much cooler it looks. Similarly Alizarin Crimson looks rather more purple than the fiery Cadmium Red.

I think it is easiest to understand the description of a particular colour as either 'cool' or 'warm' by looking at the results when it is mixed with other colours. The green on page 74 line 2, which was achieved by mixing the warm Ultramarine with the warm Cadmium Yellow, is a deep autumnal colour, whereas the cool Cerulean and the sharp, cool Lemon Yellow on the next line give a very clear bright green.

Similarly Cadmium Red mixed with the blues gives a brownish purple,

whereas Alizarin Crimson gives a cooler violet-purple (see p. 74).

Greens, purples and oranges are called 'secondary colours' because they are a mixture of two primary colours.

Each primary colour has a complementary colour which is a combination of the other two primaries. Purple is the complementary colour of yellow, green of red, and orange of blue (see p. 75 centre). These are good combinations to experiment with in your paintings because, when complementary colours are juxtaposed, the result can be an exciting, zinging effect. You won't, of course, be painting orange and blue cats, but this is something to think about when we come to backgrounds.

The three primaries mixed together will give you browns and grey-browns – warmer or cooler depending on the amount of red or blue, more greenish if you add more yellow. On page 75 (below) are some combinations of the primary colours; there are plenty more that you can try.

Earth Colours

In addition to these basic primary colours, some of the earth colours can be particularly useful when painting animals and so I am giving a fairly comprehensive list which will give you an indication of their special qualities:

Yellow Ochre: A beautiful, soft, golden colour and an absolutely essential addition to your palette.

Raw Sienna: A stronger golden pigment which gives a wonderfully sunny, translucent colour. It is good for laying down as a preliminary wash of colour which you can then build on – the warmth of the yellow will then shine through the subsequent layers of paint. I used it in this way in the painting of the tabby cat with a leaf (see p. 138).

Raw Umber: A subtle yellowish brown, it is good mixed with Ultramarine to achieve a grey.

Burnt Umber: A rich, warm brown.

Burnt Sienna: A very strong, hot brown. I often mix it with Ultramarine when I am painting a black cat. It sometimes separates out, which is an effect I like as you rarely see a completely black coat on an animal – there is often a brown or a blue sheen, depending on how the light is falling on the fur.

Sepia: A cool brown which can also be mixed with Ultramarine to get a dark, almost black colour.

Of these the most useful to have in your palette are Yellow Ochre, Burnt Sienna (a warm brown) and Sepia (a cool brown).

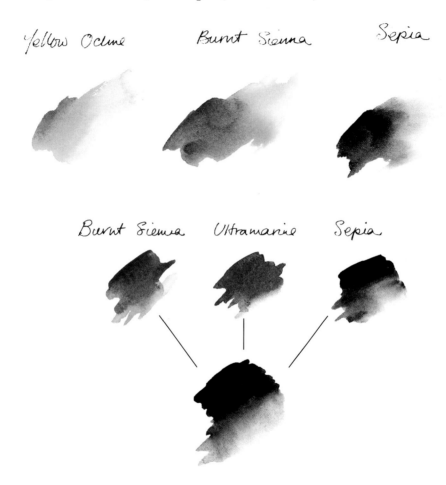

Black

I am unwilling to state categorically that you should never use a particular pigment because there are times when the use of black in a painting works wonderfully. However, black is the most difficult pigment to handle,

especially for the beginner. It sits in the palette tempting you to use it as a short cut to mixing shadows and for outlines, and, when you succumb, it can completely deaden your picture.

Outlines are to be avoided and shadows are not merely one uniform grey – they vary greatly, taking on colours from the object which is casting them. When you're painting a shadow, try adding some blue to the colour you have used for whatever is creating that shadow.

Here are some seemingly unlikely combinations which give a variety of greys. Try mixing them and experimenting with other colours, but don't use more than three pigments mixed together or your results will become muddy.

If you're painting a black cat then it does seem obvious to dip your brush straight into black paint, but, if you look carefully at the cat's coat, you'll see other colours reflected there. I often use a mixture of Ultramarine, Sepia and Burnt Sienna, because there can be a blue sheen on black fur or sometimes a reddish brown content to the coat. To achieve a hint of these colours in your painting will give it a vibrancy which plain black and grey can't.

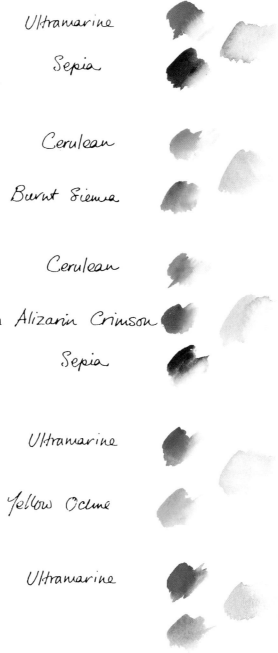

Ultramarine

Sepia

Cerulean

Burnt Sienna

Cerulean

Alizarin Crimson

Sepia

Ultramarine

Yellow Ochre

Ultramarine

How to Paint

Using Water

It seems rather too obvious to point out the importance of water in water-colour painting, but I can't emphasize enough that you need plenty of clean water. I have seen so many people trying to use tiny pots in which the water soon becomes murky and then being disappointed when they are unable to mix a clear, glowing colour.

The water carries your pigments over the paper and you need to use plenty of it; with too little water your brush strokes can become dry and stilted. I know that using water with abandon can be frightening when you are just starting – all that water and paint on the loose, you think you will have no control as to where it will go – but don't panic.

1 Mix some paint with water in your palette – use plenty of pigment and plenty of water. Now, with your brush fully loaded, put a large blob of colour on the paper. Clean your brush and, with just the water remaining on it, go back to your paper and pull the paint out from the centre of this blob of colour. Do you see how you can achieve dark and light shades of a colour by altering the proportion of water you use?

2 Tilt your paper or sketch pad slightly using a board and mix up a good quantity of paint. With your brush fully loaded and using the side of your brush, not just the tip, draw a broad line of paint across the top of the paper. Now draw another line across, under the first and slightly overlapping it. Carry on down the paper in this way, making sure your brush has plenty of paint on it as you progress, and you will end up with a uniform colour covering the surface of your paper.

This is called 'laying a wash'. Because your paper is tilted during this exercise, the water is allowing the paint to gravitate down slightly whilst you are pulling the paint across. The water is doing much of the work for you – let it do so.

3 Repeat the previous exercise, but add more water to the paint as you go. This is known as a 'graded wash'.

We need to have control over the paint and water, and to decide how much pigment and how much water is needed to achieve the depth of colour we require.

However, we also need to allow the water we use to move freely and to help us manipulate the paint. Don't fight against it and don't worry if it seems to get out of control. Have some paper towels or tissues to hand and push it back in the direction you want it to go.

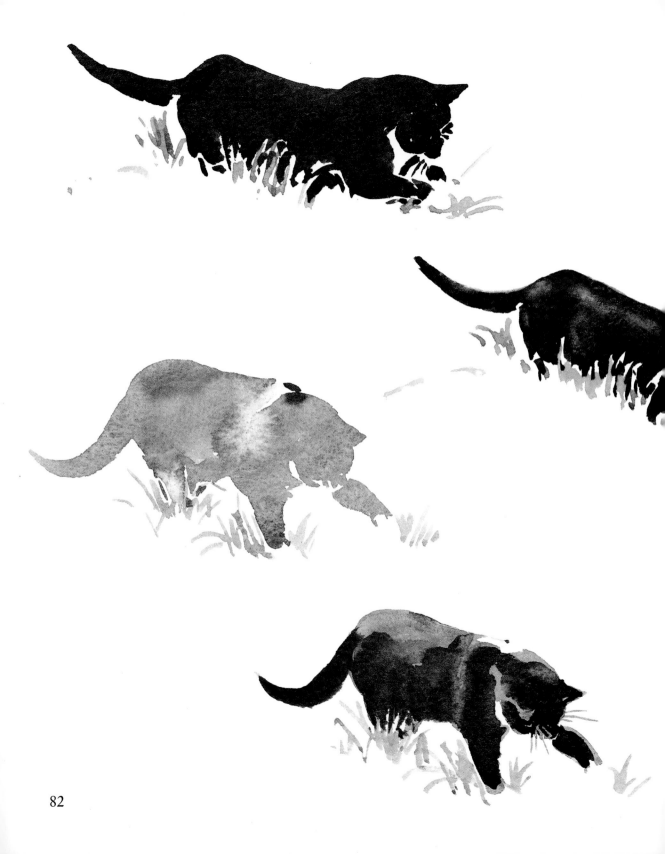

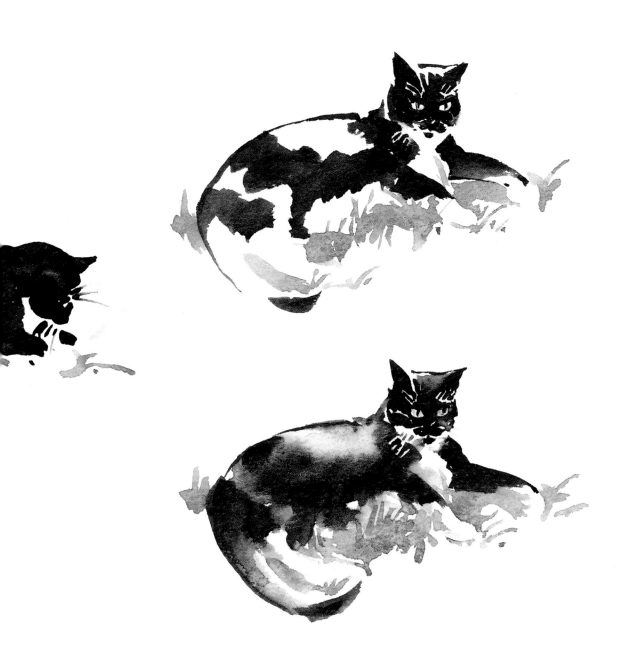

Using Depth of Paint

The paintings on this page show how, with limited use of colour and the application of more or less water to this colour, you can achieve a solid form.

Take a sketch you have already done of your cat – I have chosen a back view – and mix a large amount of one colour, the colour of your cat (or one of them, if it is multi-coloured). With your largest brush and plenty of paint, draw a broad line depicting part of its silhouette and pull the paint inward from this line over the body of the cat. Clean your brush and, with plenty of water, draw that paint over the form of the cat. Immediately you will start to achieve the effect of a solid object affected by light coming from one direction.

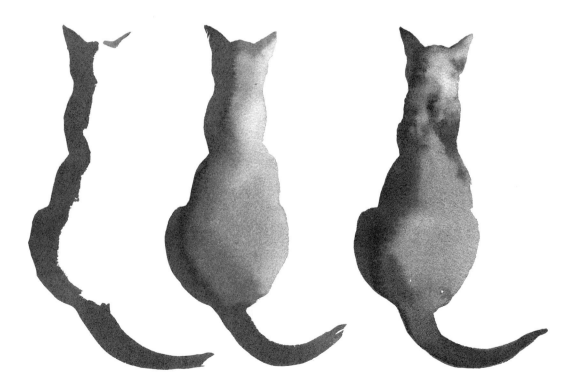

Remove the excess water from your brush and dip it back into the paint. Now, whilst the painting of the cat is still wet, you can apply any other areas of darker tone that you want. I have put some darker paint on the back, between the shoulder blades. I have used information from two different drawings to help me with this one painting.

On many occasions you will have a very short time to capture on paper what you are seeing. Perhaps you will only be able to use one or two colours, therefore the sole means you have of creating the illusion of a solid creature and not a silhouette is by varying the amount of paint you put on the paper – more water and the area will look lighter, more paint and it will look darker.

You can do this in several ways and the pictures on pages 82–83 show three methods of setting about painting Muffin, a stocky, little black-and-white cat. (Note that I have used the white paper unpainted for her markings.)

1 Put the paint down thickly on what you see to be the darkest areas and then, with just water on your brush, pull out the paint (diluted into the lighter parts).

2 Put down the paint thinly in a silhouette and then add thicker paint, building up layers of colour.

3 Paint the silhouette thickly. Then wash your brush and remove the excess moisture from it with a paper towel. If you then go over the high-lights, the paint will be lifted back on to the brush and give you lighter areas.

Tone Studies of Movement

When I was painting this series of watercolour sketches overleaf of our Burmese cats, I used the techniques I've described in the previous pages, and concentrated on trying to achieve the bulk of the cats and an impression of their movement.

The cats overleaf (p. 86) are relatively still, but, even when an animal is

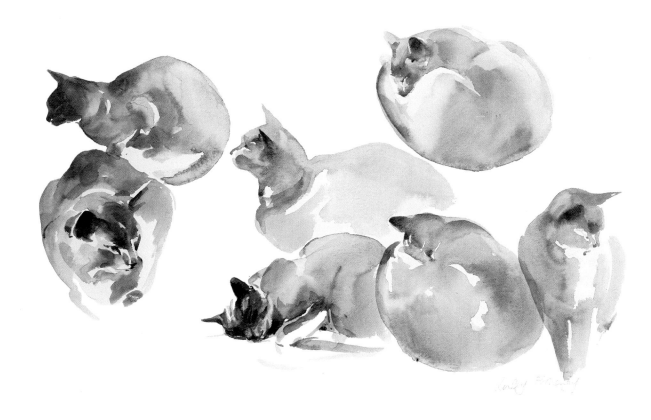

sitting, there is often a feeling of tension and imminent movement. This can be implied by the position of the head and particularly by the ears. I frequently start a sketch of a cat with the ears, before painting in a fluid line for the outline of the back and then drawing this paint out to form the body.

To help you achieve the form of the body, look again at the diagram of the skeleton and the diagrams which show the positions of the leg bones (pp. 48–49). When a cat is sitting, the long bones of the back legs are no longer stretched out, and we see a hump formed when the muscles move the femur forward and the foot is lying flat on the floor. Similarly with the front legs, the elbow joint is pushed upwards and backwards as the body of the cat sinks down.

We can see and feel the effects of these movements, and, by darkening the area around the parts where bone and muscle push skin and fur outwards, help to give an impression of the mass of the cat.

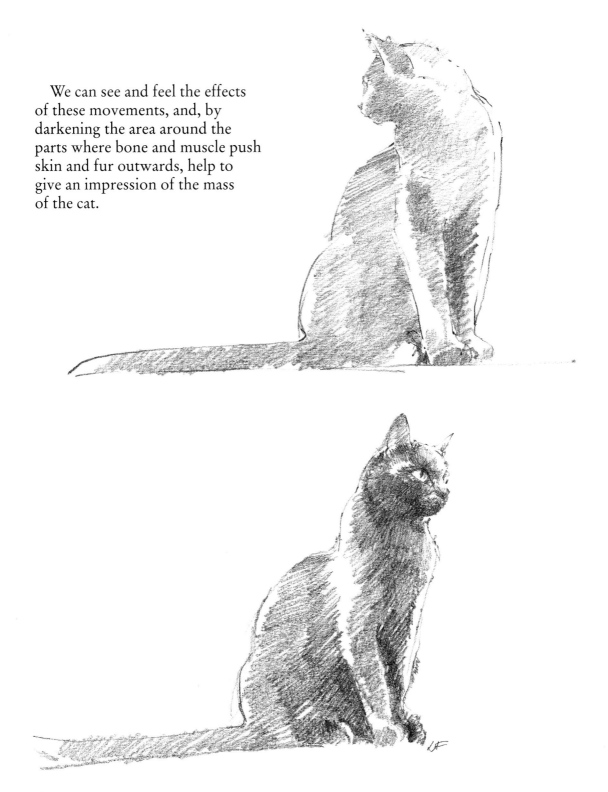

Viewed from the side, we see the chest protruding over the front legs. If we then move around to the front of the cat, we can see that this often means a shadow is cast down on to the legs and back between the legs. So we see a darker area beneath the chin (where the head casts a shadow downwards), a lighter area (where the chest sticks out) and then another darker area at the top of and between the legs.

Using one of the methods from the previous three pages, on a large sheet of paper try several sketches in watercolour of your cat as it is sitting or sleeping. You will find that, even when they are resting, cats will move sufficiently often for you to try different poses.

This next set of studies (opposite) was made as the cats started to move and I have used the positions of their tails to help give an impression of

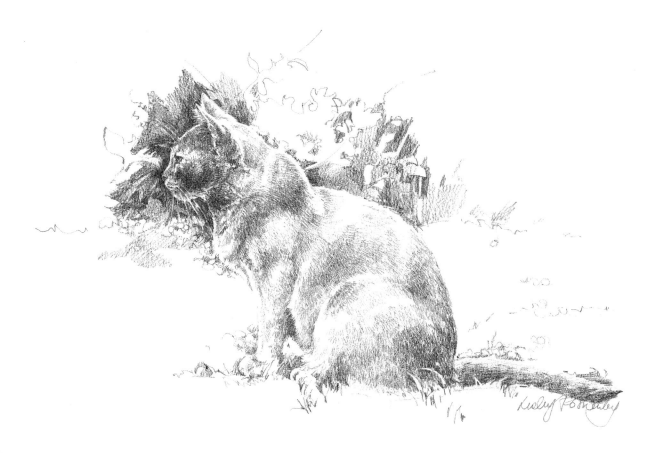

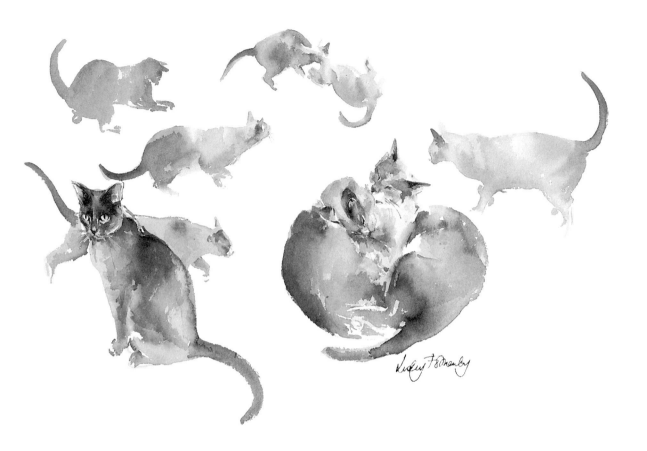

that movement. You can see how the line of the back extends into the tail. The cats were moving fairly slowly as they took up these poses and were often frozen in one position long enough for me to observe them. Sometimes things become more frantic, so I will give you some tips on how to deal with high-speed cats.

These sketches were done very swiftly of two brown Havana kittens. I mixed a quantity of paint before I started – Burnt Umber and Sepia – and I used a No 8 sable brush. Havana kittens have amazingly large ears which seem to have a life of their own, able to move into almost any position – I'm surprised they can't take off with them. So I started with the head and the position of the ears, and pulled the paint down into the body.

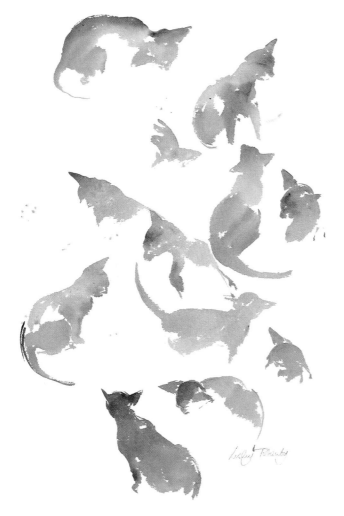

A No 8 brush will hold a good quantity of paint, so load it well when you are painting and then you can create an ear just by putting the brush once on the paper – the tip of the brush is the tip of the ear and, by pressing the body of the brush down on the paper, this will give you the fatter part of the ear, where it joins the head. *Don't* try to do a thin brush stroke for the outline and then fill it in.

The paw prints you may spot on this page were made as the kittens trotted over the wet paint while I was working. Try not to be put off when this happens or when your cat wants to come and chew the end of your pencil as you work – persevere.

Because the kittens were moving most of the time, I tried to get as many different poses as I could down on one sheet of paper, moving backwards and forwards between sketches if a pose was repeated.

If you want to remember a pose and put it down on paper, why not use the 'eye as a camera' technique described earlier? Look at the cat, shut your eyes and, keeping your eyes closed, look down at your paper, open your eyes and paint as much as you can from memory.

Some cats, like this strongly marked ginger tom (opposite), necessitate more than one colour in order to paint them. Speed was just as essential as

when I was using only one colour and so, as before, I mixed the colours I thought I would need before starting to paint.

Always look carefully at the cat before you begin and do as much preparation as you can prior to putting brush to paper.

For this painting I mixed Yellow Ochre, Burnt Sienna and Cadmium Yellow for the background colour of the cat, and a stronger mix (less water) of these three colours plus a little Sepia for the markings. I also made up a small quantity of Alizarin Crimson and Cadmium Yellow for the eyes.

When I was ready to start, I worked in the palest background colour in the same way as I would if I were painting a cat with no markings. I then had down on paper all the information I needed about the pose and it didn't matter much if the cat had moved by the time I was putting the markings in. I could see the patterning on the animal and was able to work out how the marks would fit in with the pose I had already put down. (Look back at pp. 63–65 to see how a cat's markings follow its form.)

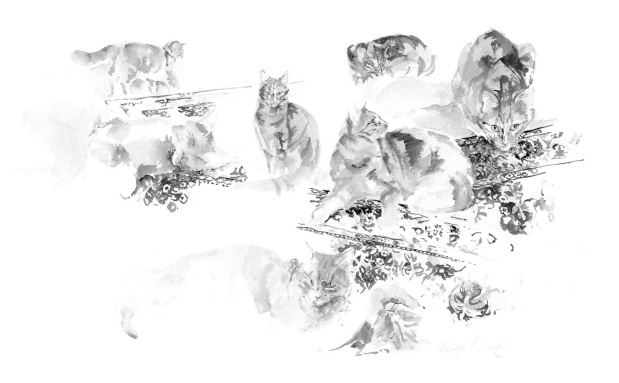

As before, I moved from sketch to sketch and back again as the cat resumed certain poses.

These sketches differ from the ones on the previous pages in that I have started to introduce some background. The patterned carpet made a good foil for the exotic colour of the cat and helped to place the cat in an environment rather than leaving it floating apparently in thin air.

Markings

When you were building up the three-dimensional form of a cat using only one colour you were using a lot of water with the paint to obtain a fluid effect and to allow for the greatest contrast in tone, sometimes working wet paint into wet paint.

When you are building up markings on the body of a cat in a painting, you must wait until the paint is drier before you put on the darker colour. It doesn't have to be bone dry – sometimes lines which merge into the background colour are very effective – but, if the paint is too wet, the darker colour on top will simply disperse into the pale colour beneath and you won't produce enough contrast.

Try painting an area of pale colour and then, with a more intense colour, paint on top of this. Experiment by painting on to it when the first layer is very wet, and then try again as it dries. You will soon become aware of the different effects you can achieve.

Pattern on Cat and Background

Sometimes the pattern on a cat is echoed in the background. This tabby (overleaf) was lying on a striped cushion and I did the four studies as he slept; he moved gently from one position to the next while I painted him.

I used Raw Umber and Sepia for the colours of the cat, working in the same way as for the ginger tom on page 91. Jacob was curled into a round shape as he slept, so the lines on his body became broad curves.

I have used similar wide lines for the cushion to echo the pattern on the cat and I felt that the curving lines joining the studies helped to indicate the way he was turning round in his sleep. Because the lines on the cushion are curved in towards Jacob's body, they are not only decorative but also indicate how the soft cushion was distorted by the weight of the cat. If you look back to the exercises you did with lines (on p. 62), you will realize that we need no information other than the direction of the lines to tell us what is happening to the cushion.

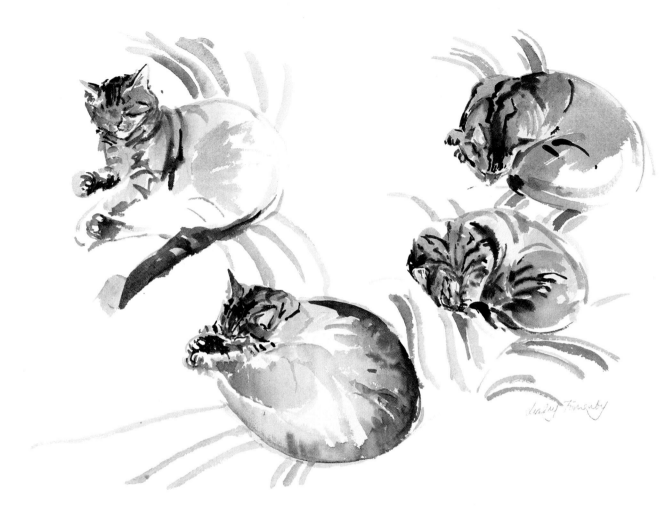

The cats and kittens in the painting opposite are also on a striped background, but in this instance I have used the stripes to contrast with the cats rather than to echo the pattern on them.

The pale body of the Siamese shows up her dark markings and the shapes of the brown kittens lying against her. There was an interesting juxtaposition in these dark and light shapes. I have used the colour in quite a flat way, not bothering too much with the three-dimensional forms of the cats, but more with the patterns they make together. The small striped areas are a useful device for contrasting with and breaking up these solid shapes.

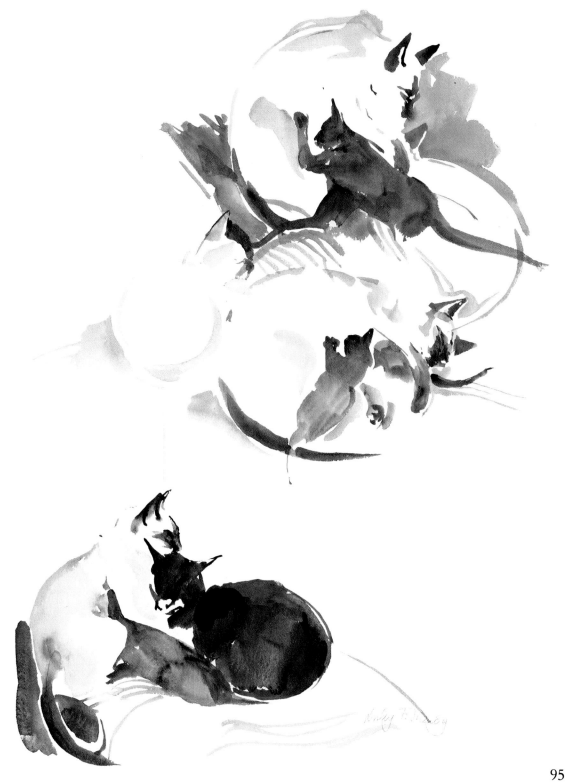

Problems

Cats whose colouring is in the middle of the tone range – grey animals, for example, or tabbies without distinctive markings – don't present as many problems to painters as do those at the extreme ends of the tonal scale: black and dark brown at one end of the scale and white at the other. With a grey cat we are aware of a wide range of tone when we look at it, so it is easy to see where to put dark shadows and where to leave areas nearly white. We can show the form relatively simply, as we can with distinctively marked cats, because the markings help to describe the solid mass.

White Cats

The problem of how to paint a white cat on a sheet of white paper is seemingly an impossible task.

You can't paint the cat in white, so you have to paint the background and leave the cat to show up against it, i.e. look at the negative shape, paint that in and the positive image will appear. To do this, start by painting in a line for the back and head in the background colour. Then, instead of pulling that paint inwards to show the bulk of the cat, draw it outwards to represent its surroundings. This method is like chipping away at stone – you can then modify this shape by 'biting' your way into the original silhouette with your brush. Keep the paint wet whilst you are doing this and you won't end up with a line round the cat, but a solid area of colour which finishes as the cat starts.

Try this first of all by choosing a line drawing which you've already done. Mix plenty of one colour and, with your brush fully loaded, reproduce part of the outline of the sketch on to a piece of watercolour paper – keep the point of the brush following the outline and the reservoir of the brush lying on the paper towards the outside of the line. Now, while the paint is still wet, load your brush again and pull the paint further out and away from the outline.

The paintings of Bryony overleaf (p. 98) were done in this way. The background cushions were painted first, using Yellow Ochre, Cobalt Blue and Cerulean, and I have mixed these colours together for the shadows on

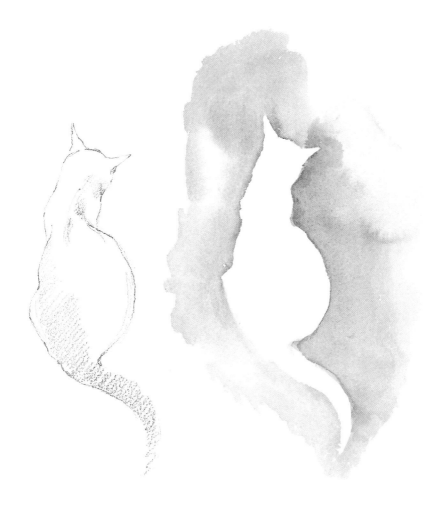

the cat's head and body. Her ears were painted using Alizarin Crimson and Cadmium Yellow combined.

Black Cats

The painting overleaf (p. 99) shows two poses of a very dark brown Foreign Black cat washing. Foreign Blacks are short-haired cats and in build they are like Siamese. I was interested by this pose because of the extended foreleg, which provides a strong L-shaped outline, and the tension in the head pulled over and away from this leg.

On my palette were Ultramarine and Sepia, plus some very dark brown mixed from these two colours. I started by painting the elongated leg in

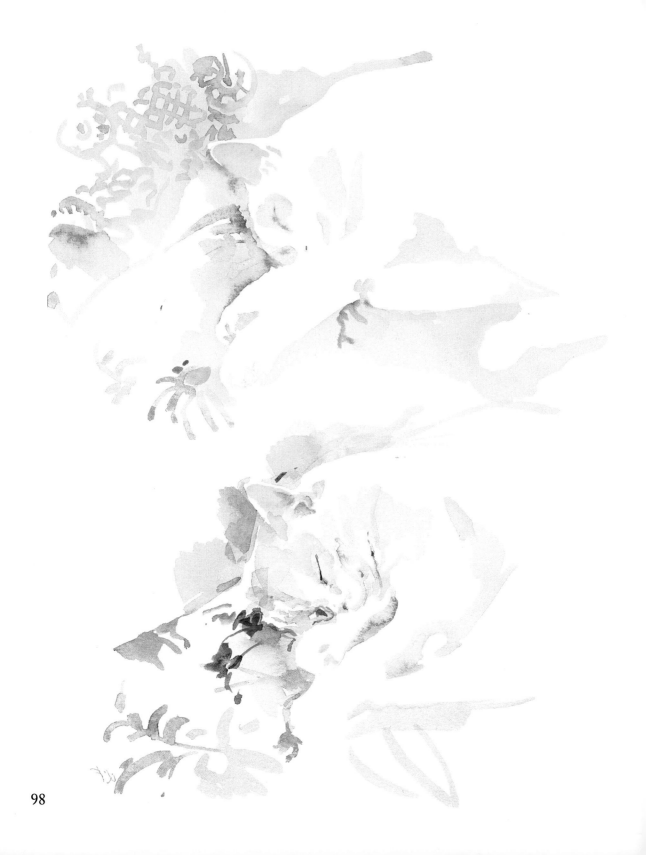

98

this dark brown, starting from the paw and moving upwards. Then I put my brush into water and, with just water on the brush, pulled this long shape up and around to form the shoulder and head. The colour has separated: you can see the blue on the back of the head – it indicates the sheen on the cat's coat and I accentuated it in places by adding a little blue while the paint was still wet (on the back of the head in the bottom sketch).

For the darker brown on the head, ears and face I went back to the mixed brown, leaving a space for the curling tongue.

The few lines of colour around the cats give an idea of their surroundings and make them look as if they are on something solid rather than floating in the air. The background also enabled me to create a white space around the head and ears which emphasizes the feeling of light falling on to the top of the head and shoulder. Don't be afraid to leave some parts white.

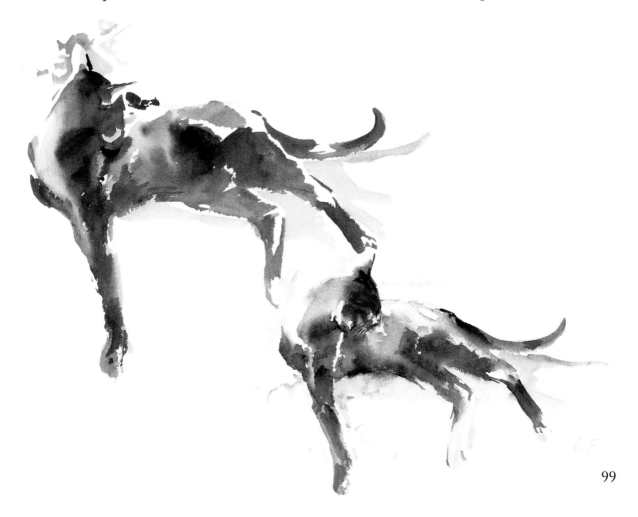

This is also a sketch of a partly moving cat. I made this task easier for myself by beginning at a point which was static. I put in the line of the paw to give myself something to relate the rest of the picture to and then I painted the head (the only moving part) in one of its positions as it moved up and down. To do this, look at the head, shut your eyes, look down at the paper and paint what you have just seen. If you have to look back to obtain more information, wait until the head moves again into the position you are painting and then repeat the process. After that you can forget about changing positions because the rest of the cat is at ease.

Mixed Media – Watercolour and Pencil

All of the sketches we have looked at so far have been in either paint or one of the drawing media. However, in the same way as we can produce a drawing with anything which makes a mark, so we also have the freedom to mix any or all of these media together.

Pencil and paint can be combined to give a linear effect with solid areas of colour. The only thing to beware of when using this combination is of making a drawing and then being too restricted by the lines you have put down. When you start painting, don't try to fill in the spaces between the lines too carefully – this will make the piece of work lose its spontaneity. It doesn't matter if you paint over lines or if you put paint down and then draw over it. In fact, working simultaneously with paint and pencil can be very freeing.

This sketch was done on Bockingford watercolour paper which is cold pressed and has a 'not' surface. The grain of the paper has produced an interesting pencil line. (Have a look back to pp. 42–43 and see how the paper you use affects the drawing medium.) The texture of the paper is particularly obvious in the shaded areas.

Pen and ink drawing can be combined with watercolour painting (p. 102). Use a non-water-soluble ink and draw in the lines of the animal as swiftly as you can before adding the paint. The lines you draw with pen

and ink will be stronger than those using pencil and so it is even more important to use them only as a guide and not try to fill in spaces too carefully.

Watercolour Crayons

Watercolour crayons combine in one medium a textured or linear effect with the softness of watercolour. They are water-soluble sticks of colour which can be used as an ordinary crayon or pastel, or with the addition of water as a watercolour paint.

As you can see, the colour is pulled out from the crayon line and can be mixed on the paper with other colours in the same way as conventional watercolour paint. The mark of the original line remains after you have added the water; don't try to get rid of it – it is a characteristic of the medium and you can make use of it, as we will see later.

The two examples below show the same crayons used on papers with different surfaces. On the left is Arches watercolour paper with a smooth hot-pressed surface and on the right is Bockingford, a 'not' surface paper.

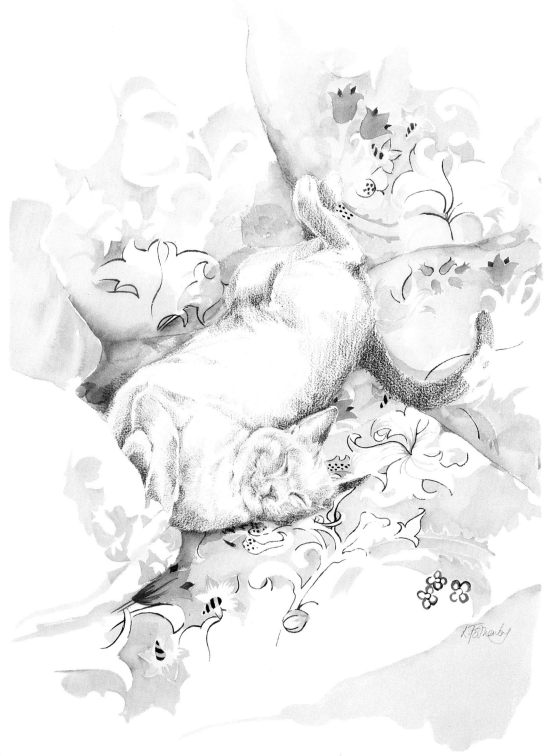

Because the paper surfaces are different, the initial crayon marks are not the same. The lines are rougher and more broken on the 'not' surface paper. As the paint is pulled out of the crayons, the contrast is felt rather than seen. Paint on hot-pressed paper tends to slide over the surface more than it does on a textured paper, where the grain holds more paint.

In this sketch below of Max about to pounce I wanted to create the effect of imminent movement and so I used a very broken line for the cat's outline, particularly over the back and head. This means that the line is more difficult for our eye to follow and we have to look carefully to ascertain where it is, as we would when something is moving. A harder, more definite line would create the impression of something static.

This broken line and the areas left white on the cat's back also give the feeling of light from above, contrasting with the darker, denser parts on the sides and under the cat, where I have used more crayon and pulled more paint out from it. I began this drawing by sketching a rough outline faintly with a crayon and then worked in solid areas of tone, breaking these areas into stripes as I went along. The marks made by crayon, still visible under

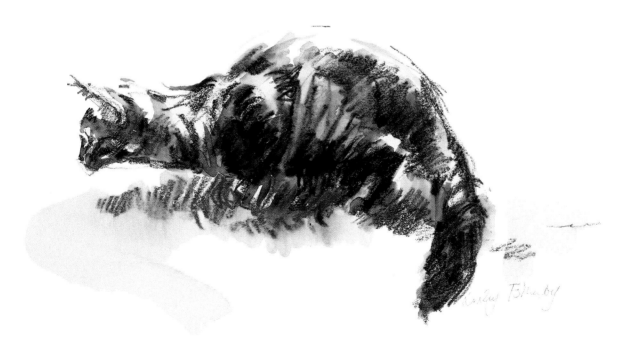

the paint, can also give the impression of movement and a feeling of the texture of the cat, in this instance a long-haired tabby.

Whatever drawing tool you are using, try to make the lines you put on the paper follow the direction of the animal's fur (the direction in which you would stroke the cat).

White Paint and 'Body Colour'

So far we have used only watercolour paint and relied on its transparency to provide highlights by letting paper show through. Good watercolour paper has a light-reflecting surface which gives sparkle and light to the paint applied to it. For white areas we have used the white surface of the paper untouched by colour (look at the previous page and the white light on Max's back).

White paint is, by its very nature, opaque. It won't show up on white paper, of course, but it can be used on tinted paper with watercolour or as

'body colour' (see p. 107) on top of watercolour paint to emphasize high-lights. It can also be sandwiched between layers of watercolour paint, but it takes a great deal of care to do this without the layers mixing and becoming cloudy, so I am going to concentrate on its first two uses.

White watercolour paint is called Chinese White and white gouache can be obtained in tubes of Permanent White and Zinc White. Of these, Zinc White is the more transparent of the two. Permanent White will give you better cover. Having said that, the difference is minimal and you can use either to useful effect.

In the sketch below I have worked on Mi-Teintes pastel paper with white gouache and watercolour.

I started by painting with the white gouache only, blocking in the areas of white fur which I could see on the cat, but also putting on white paint where I saw light areas even if they weren't actually white. This meant that, when I came to put on the colour, I had the freedom to lay it over both the tinted paper and the white paint, and so with the same colour achieve different tones. The backgrounds show through the transparent paint and thus affect it.

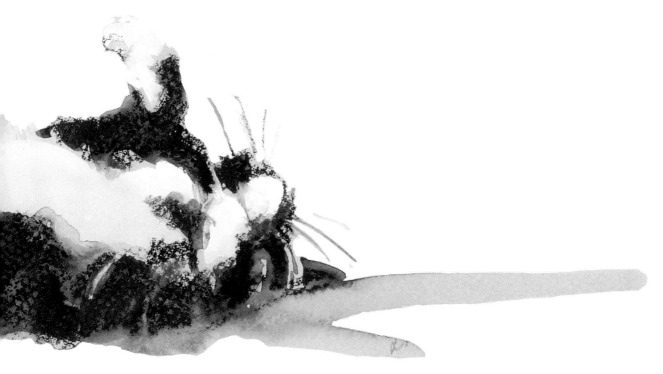

In the examples above I have painted white gouache on to pastel paper in two ways to show you how to achieve different effects. On the left I have used it quite thickly (not too thick or it will crack) and, because the paint is fairly dry, it has allowed me to pull it over the textured paper and for us to see the honeycomb pattern on its surface. On the right I have used more water to achieve a softer effect.

You can see how much the tinted paper changes the colour of the water-colour paint. The same colour looks entirely different when it is painted directly on to the paper rather than over the gouache. In this instance the paper colour is very strong, but you can buy lightly tinted watercolour paper, which does have the effect of unifying the paint laid on it by slightly tinting all the colours.

A light touch is needed when putting watercolour over gouache. Don't scrub away too hard with your brush – remember you are putting one layer of paint on top of another and, because they are both water soluble, this needs some care.

Body Colour

The term 'body colour' describes white paint laid over watercolour paint rather than underneath it. I use this method chiefly when I am doing a detailed watercolour and I have already built up several layers of paint. I can then get the final sheen on a cat's coat.

Using the watercolour methods I have described earlier (see pp. 80–85), I carry on building up layers of colour until the paint is quite thick and this layering in itself gives a sheen to the paint. When the painting is almost complete, I use a fine brush, a No 1 or 2, and add white gouache as dryly as possible to the very lightest parts. This emphasizes the sheen on the coat. Sometimes I then lay a very dilute wash of watercolour paint over some of the body colour. In the painting below I have used Burnt Sienna over the white. This is the method I described earlier as sandwiching white paint between layers of watercolour. Don't attempt this until you have experience of handling paint and then use a very delicate touch.

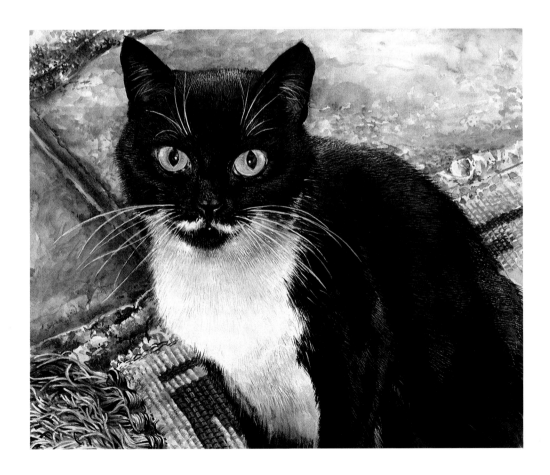

Choosing Backgrounds

So far the backgrounds to the cats
we have been painting have been
minimal, merely a suggestion of
their surroundings. Once you have
done several drawings and water-
colour sketches, however, you can
think more about the situations
in which you want to place your
cats.

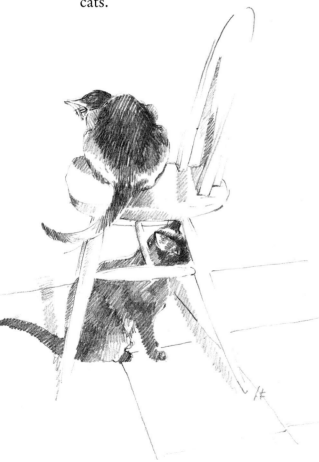

It is extremely unlikely that
you'll be able either to put your cat
into the middle of a still-life and
expect it to stay there or that your
cat will lie about somewhere in the
house long enough for you to paint
all of the chair, cushions or what-
ever else there is around. So, you
will probably have to think about
constructing a picture.

Having said that, I did once
paint one of our cats actually in the
middle of a still-life because,
having removed her three times
from the chair which was a part of
it, I gave up and included her.

In the unlikely event of such a thing happening to you, make some quick sketches of where your cat sits, how big it is in relation to a window, chair or whatever. The sketches need only be brief.

If you have more than one cat, try some quick sketches to show how they relate to one another.

The painting overleaf was done using sketches I had made of two seal-point Siamese. I decided on the poses I would use after looking through a series of drawings and then I set up a still-life into which I thought they would fit.

I have a device which I use to give me an idea of the bulk of the cats and how they would 'sit' in a painting like this. I take a plastic carrier bag and fill it with peanuts (we keep a large sack in the garage for feeding the birds) until it becomes like a bean-bag of the right size. I wrap a piece of cloth roughly the right colour round this and put it amongst the group of objects. It doesn't look like a cat, but it helps me to see how the animal relates to its surroundings.

Having placed these strange devices in the still-life, I drew in paint the points of the cats, did some work on the other objects, went back to the cats and so on.

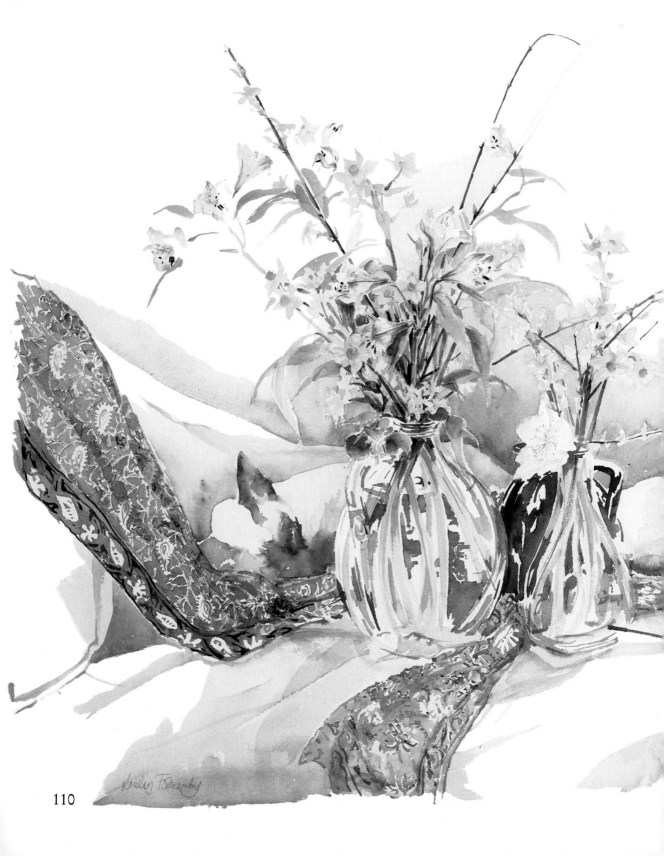

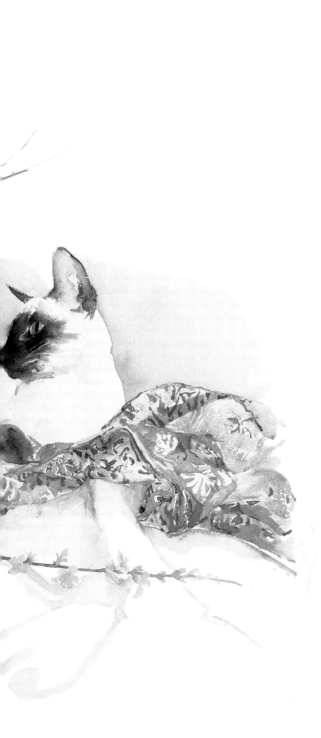

In a painting like this don't paint the cat in completely and then put the objects around it because the cat will look separate, as if it is cut out, if you do this. Try to work on the cat and the background simultaneously.

Look through the sketches you have done and see if there are any you would like to make into a painting. Choose a pose like a cat on a windowsill, by the fire or on a favourite chair so that you don't, at this stage, have to set up a still-life – use objects which are already around you. Now make some additional pencil sketches of the part of the room you have chosen and then add these to the first sketches of your cat.

When you have something you like, you can start to paint on a fresh sheet of paper.

The Venetian cat overleaf is lying on a windowsill between the window and the grille outside – it is sandwiched between the two – and so we can easily see how it relates to its surroundings. Because the grille is in front of the cat, the cat's shape is chopped up by the rectangles which these bars form. When I was planning the picture, this was helpful in that I could judge whether my drawing of the cat was accurate by looking

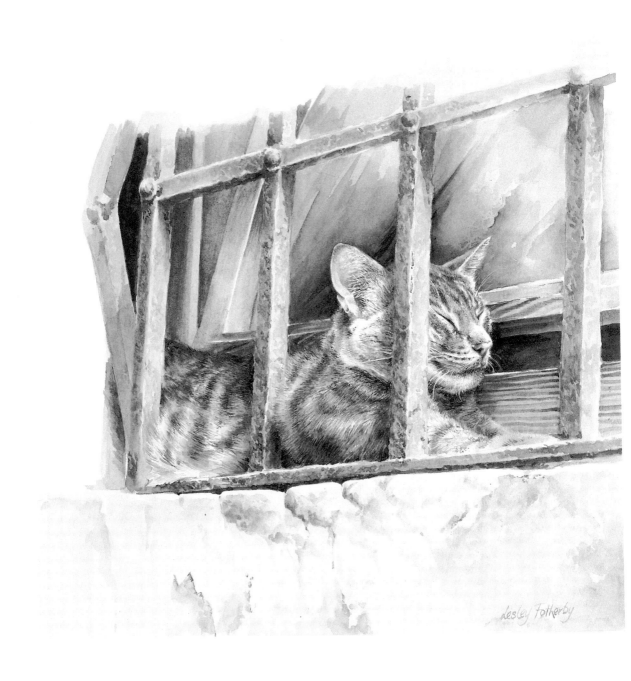

not only at the animal as a whole but also at how each piece of it fitted into each rectangle. (Look at the negative shape in the rectangle as well as at the positive shape of the cat.)

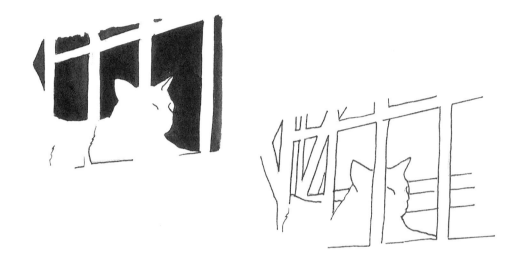

The strong vertical lines of the bars are also useful in the composition. They contrast with the horizontal pose of the cat and form interesting geometric shapes when they are seen against the frame of the window.

When you are placing a cat in a composition, remember that the cat will change what is around it (cast shadows, disturb fabric, etc.) and, similarly, the cat will be affected by its surroundings. (See also tips on composition, p. 133.) As we have already discovered, the most important element which affects the cat and helps relate it to its surroundings is light – where it comes from and what shadows are cast by it over and around the cat.

In this painting we see that the shape of the cat is changed subtly by what it was leaning against. The pressure of its body against the hard bars caused one side of its face to be pushed up, altering the angle of the eye, and the grille pushed into the fur so that the body overlapped the bars at the bottom.

Any interplay you can find between your cat and what is around it will help you to place it firmly within its context and you won't end up with a floating cat!

Scale

In previous pages you have looked at your cat in relation to the objects around it and you will have noticed things like how tall it is compared with the height of a chair leg or how much of a cushion it covers when it is lying on the chair. You will have seen how it relates to its immediate surroundings. Now we are going to take this one stage further by extending the area around the cat and seeing how it fits into this broader canvas.

In the pictures on previous pages the cats are very close to the objects we have compared them with. The distance between what is in front of the cat on page 112 and the window behind it is so small that I did not have to worry about how the size of objects changes according to whether they are near to you or far away.

If, however, we want to put the cat in a garden, we need to be aware of not only its relationship to nearby objects (such as the bird table in the picture opposite) but also what is near us (the bird in the foreground) and what is further away (like the wall).

Objects close to us appear much larger than those farther away. The size difference is often more dramatic than we realize and you can illustrate this for yourself by measuring something close to you and comparing it with something further away.

Use the method shown overleaf on page 116. Take a pencil and hold it upright in front of your line of vision; stretch your arm right out when you do this, don't bend your elbow at all. (Like this the pencil is always the same distance from you; closer or further away and your comparisons won't be accurate.)

Next measure something quite close to you – the head of a person sitting near by or the height of a cup on a table. Do this by lining up the top of your pencil with the top of the head and move your thumb down the shank of the pencil until it is in line with the chin. You have a measurement now with which to compare anything you wish.

Keep your thumb in place and swing your arm around until the pencil is in front of an object further from you, perhaps a chair across the room, then look at the measurement you have for the head against this chair. It may be that the distance between your thumb and the top of the pencil is

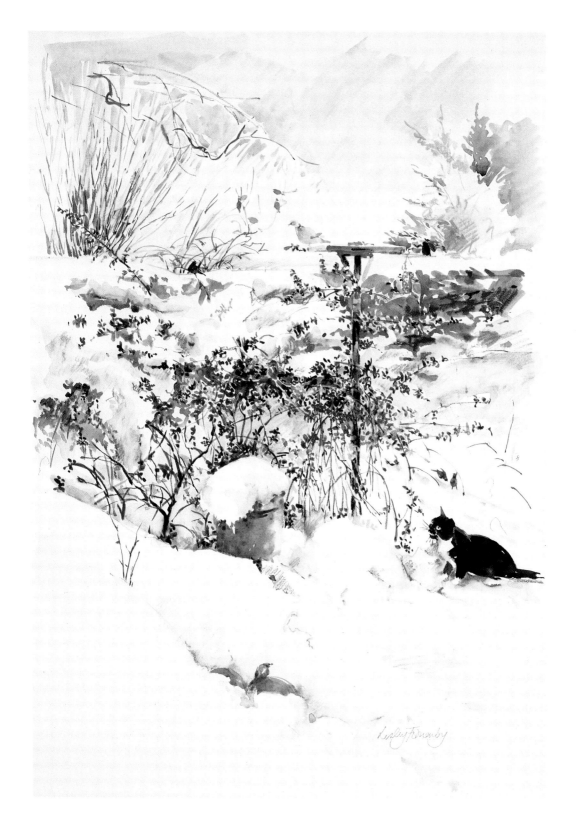

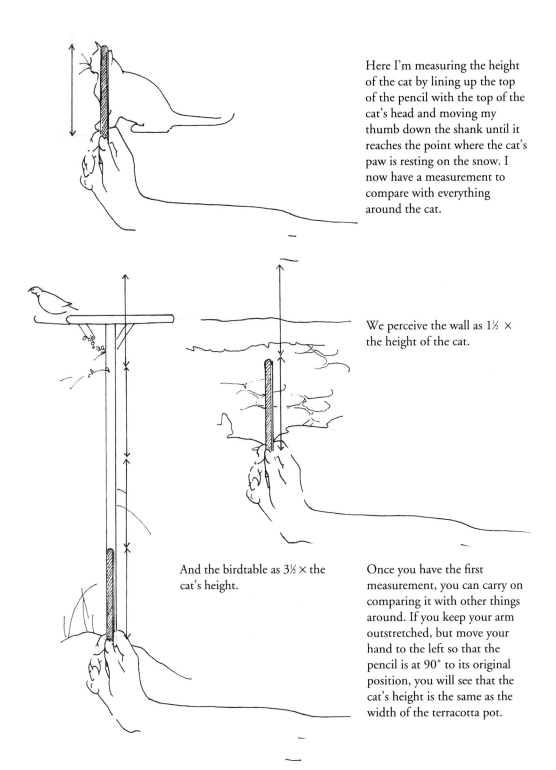

Here I'm measuring the height of the cat by lining up the top of the pencil with the top of the cat's head and moving my thumb down the shank until it reaches the point where the cat's paw is resting on the snow. I now have a measurement to compare with everything around the cat.

We perceive the wall as 1½ × the height of the cat.

And the birdtable as 3½ × the cat's height.

Once you have the first measurement, you can carry on comparing it with other things around. If you keep your arm outstretched, but move your hand to the left so that the pencil is at 90° to its original position, you will see that the cat's height is the same as the width of the terracotta pot.

the height of the chair, maybe more. We know that someone's head is nowhere near the actual size of a chair, but it is the distance from us which makes it appear so.

Once you are at ease calculating the relative size of one object compared with another, you are ready to tackle more complicated compositions because you can think of the picture not only on a flat plane (all its components roughly the same distance way from you) but also in another dimension altogether.

Colour in Backgrounds

The coloured sketch overleaf is of a tortie-point Siamese. She is a pale cat, so I have used the technique I described on page 96, where we looked at the problems of painting white cats. Here, too, I have used the background colours to show her shape.

The cat was sitting on a rug and in the background was part of a carpet, which you can see behind the top of her body. I have altered the colours in the cat to give unity to the sketch. For the Chinese rug I have employed a mixture of Ultramarine and Brown Madder, and for the pattern on it Cerulean Blue. Brown Madder and Ultramarine give an intense colour which weights the picture – the cat looks firmly sat on the mat – and contrasts with the darker points on the legs and back of the cat.

I mixed a little Sepia into the above colour for the darker parts of her body and for her face. I used a little Raw Sienna with Sepia for her ears.

The carpet which shows up the top, pale part of her body is painted in a mixture of Brown Madder and Raw Sienna. I used a dilute mix because I wanted a pale colour which would recede.

Apart from the tiny bits of Cerulean Blue on the carpet, I have painted all the picture using just four colours mixed with each other in varying proportions – Brown Madder, Ultramarine, Sepia and Raw Sienna. Limiting the colours in this way can give harmony to a study.

The studies overleaf below are of the same cat without the rug. I have used only the colour of the carpet to show up the parts of her body which

are very pale. Using paint in this way is like whittling away at a piece of wood to make a carving. You are whittling away the white paper with your paint to achieve the shape you want.

(A rather enjoyable exercise you can do to illustrate this process is to take a biscuit and draw it. Take a bite out of it and draw it again, another bite and so on. You are removing bits of the biscuit to change its shape, just as

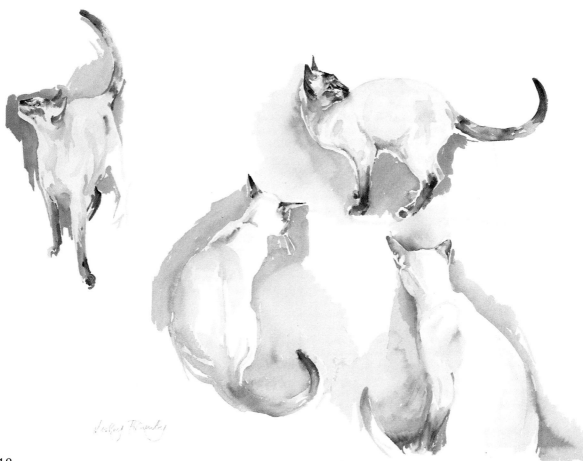

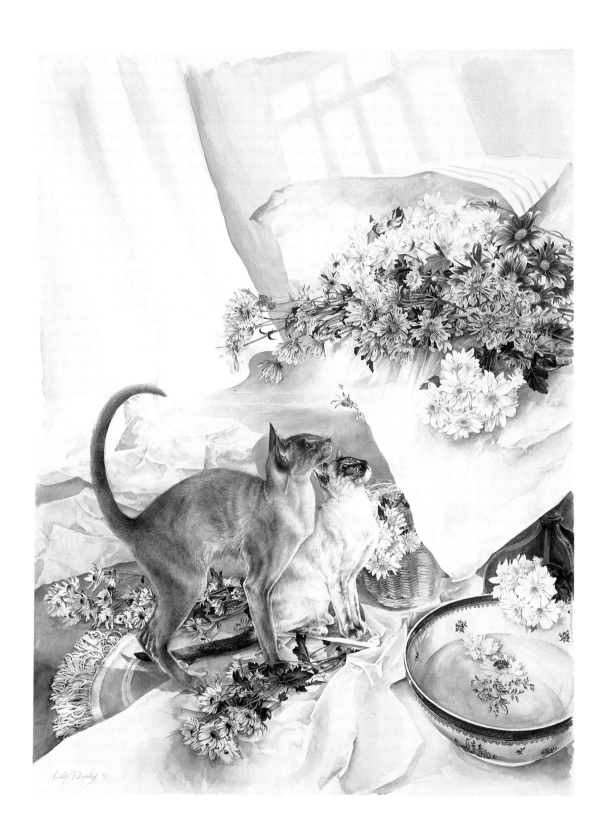

you are removing bits of the white paper to change the shape enclosed by the paint.)

To achieve form within this shape I have worked with a mixture of Sepia and Raw Sienna, a lot of pigment for the dark points of the cat and a lot of water for the shadows on her body.

After I had made studies and sketches of Soraya and her brother, a blue Siamese, I painted the detailed picture on the previous page. As you can see, I have once more limited the range of colours to pinks, browns and blues. I felt the subtle colourings of the cats suggested this. Other paintings will show you how you can use colour in a different, less harmonious way.

Observing and Collecting Reference Material

Before I had painted these pictures of Siamese cats I had not had much experience of them as a breed and I knew that unless I was able to observe them – to have direct experience of what they looked like, what colours they were and how they moved – I would be unable to paint and draw them properly. Hundreds of photographs won't tell you, for example, how a breed of cat with particularly long back legs like a Siamese will move. You have to see them and feel them for yourself.

The Siamese Cat Association was very helpful and introduced me to Ken and Wendy Long, who kept and bred Siamese, Havana and Foreign Black cats. Through their great generosity I was able to spend hours on their floor, drawing and painting. On my first visit I observed and drew as the elegant cats moved around. Wincey, the chocolate-point Siamese, was in kitten and Wendy suggested that I might like to come again when the kittens were born and follow their development. Wincey had three kittens: two males, who were Havanas, and a female chocolate-point Siamese. Ken and Wendy's children named them Tom, Jerry and Lady.

The drawings and paintings on these pages are some I made during the following months and I include them here in the hope that they will help you to see how to gather information and build up knowledge of what you

want to paint. I had a marvellous time doing them and I'm sure you will find observing and drawing your pets equally enjoyable.

I made some sketches of the kittens when they were a few days old. As they grew, I was able to get closer for longer without fear of disturbing them and to make some watercolour studies.

The Siamese kitten was very pale as her points hadn't developed at this time (pp. 122–23), but the two brown males showed up in sharp contrast against their mother and I was able to manage with very few colours when I was painting them – much of the time just Sepia and Ultramarine. The juxtaposition of shapes made by the kittens and by Wincey's dark points was so interesting that at this stage I concentrated almost entirely on the patterns these created rather than putting much emphasis on the form of the cats.

The pencil drawings on pages 124–25, made as they grew, show Wincey suckling and washing the kittens. I have thought more about her form and the line of her body as she bends over them in these studies. Remember the fluid line that follows the spine and continues to form the tail. This is important here.

Wincey, Lady and one of the Foreign Black cats, Penny, make an interesting combination on page 125 (below). Lady was much bigger by now, over two months old, and by this time Penny was sharing in the care of the litter: every time they got out of their box she would hastily pick them up by the scruffs of their necks and bundle them back in. I like the positions of these three cats mostly because of the shape of the dark head peering round the two Siamese and giving weight to that side of the drawing.

For the detailed painting of Wincey and her kittens on pages 126–27 I used some of the many sketches I had collected. I painted it at home and so I set up the basket and fabric as a still-life once I had decided on the positions of the cats.

When I am doing a complicated painting like this, I set it up as I have described on pages 109–11, but rather than going straight in with my paint brush as I did with the painting on that page, I do a little drawing of the cats and some of the objects around them. But I keep that drawing to a minimum. I use an F pencil (an HB will do) and I sharpen it to a very fine point. The line I can make with this is delicate without indenting the paper and it disappears when I start to paint. Sometimes I draw straight on to the

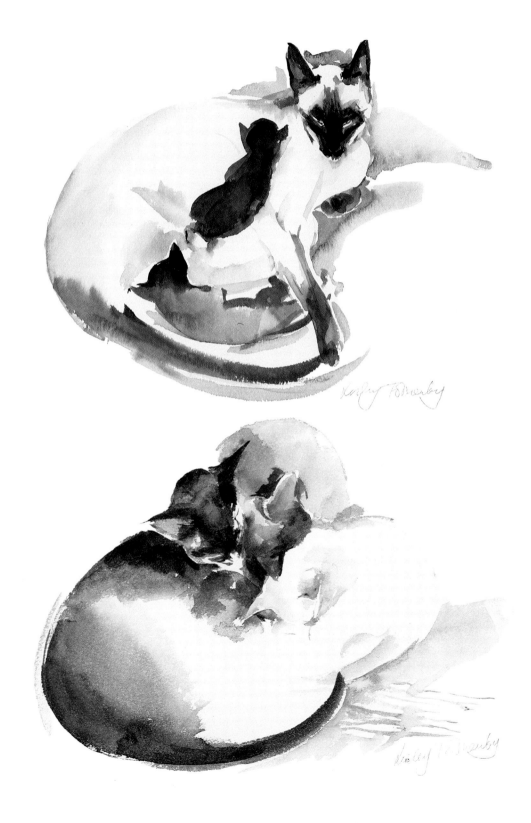

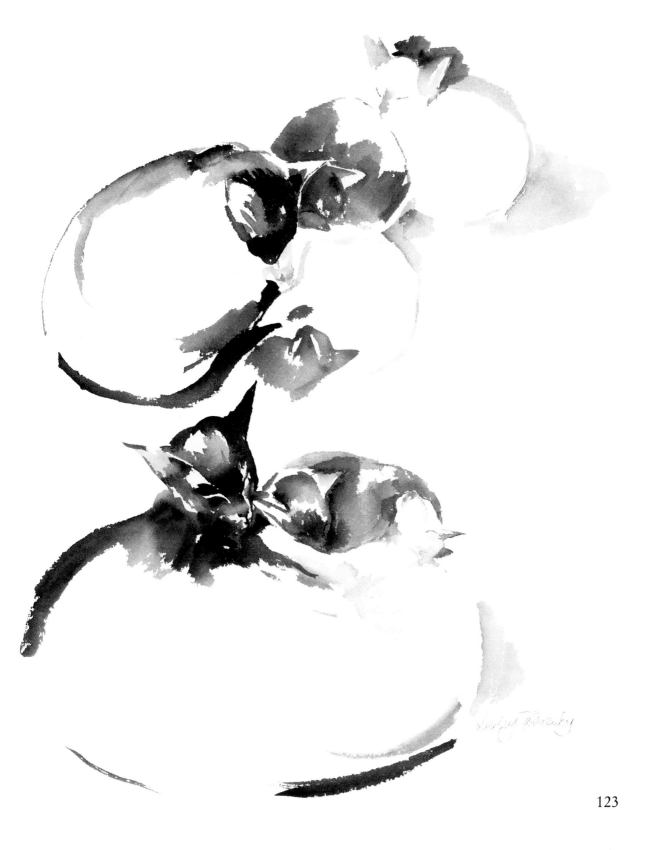

123

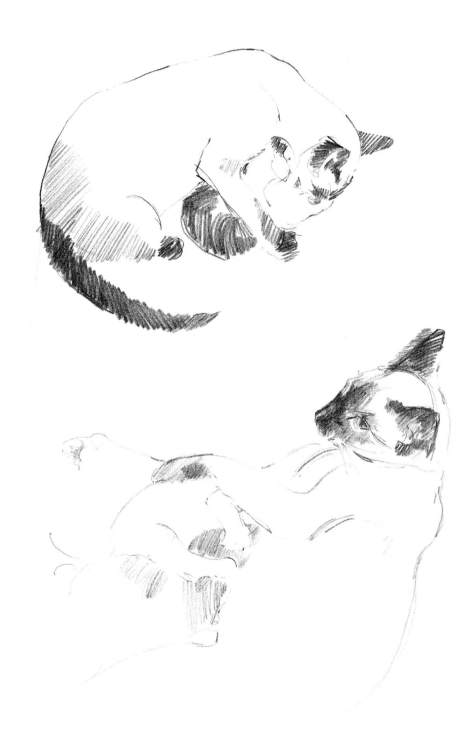

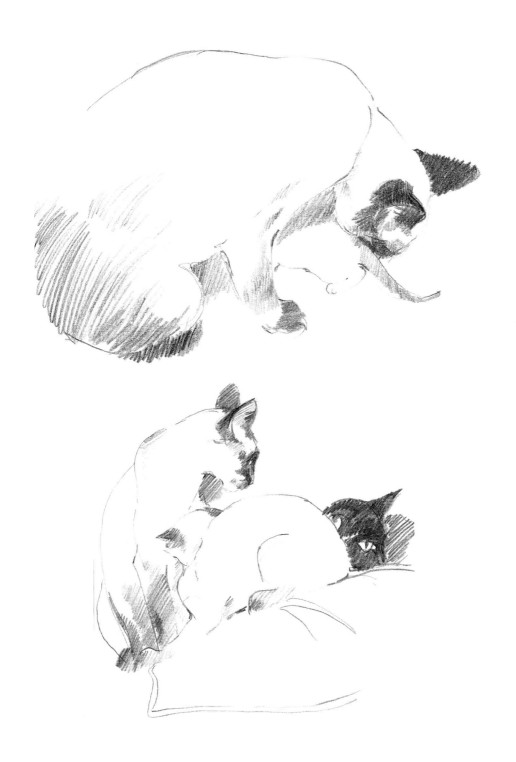

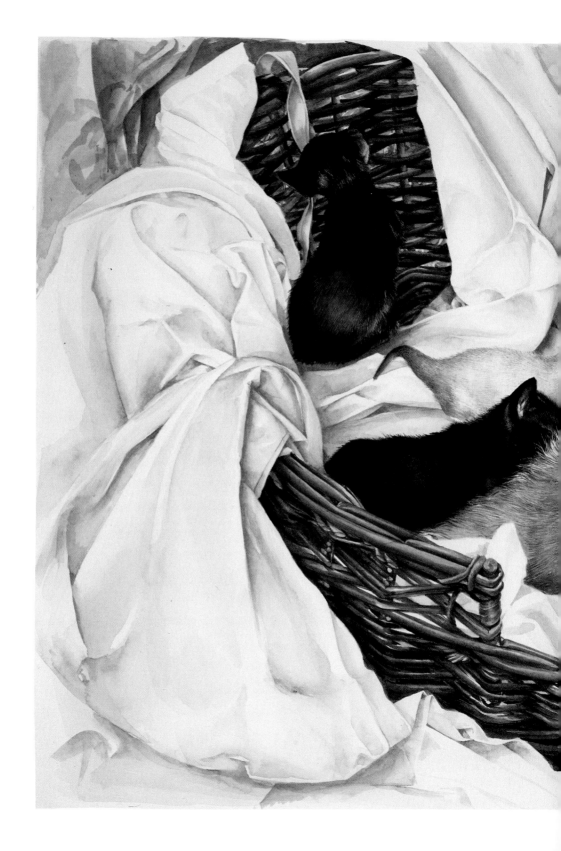

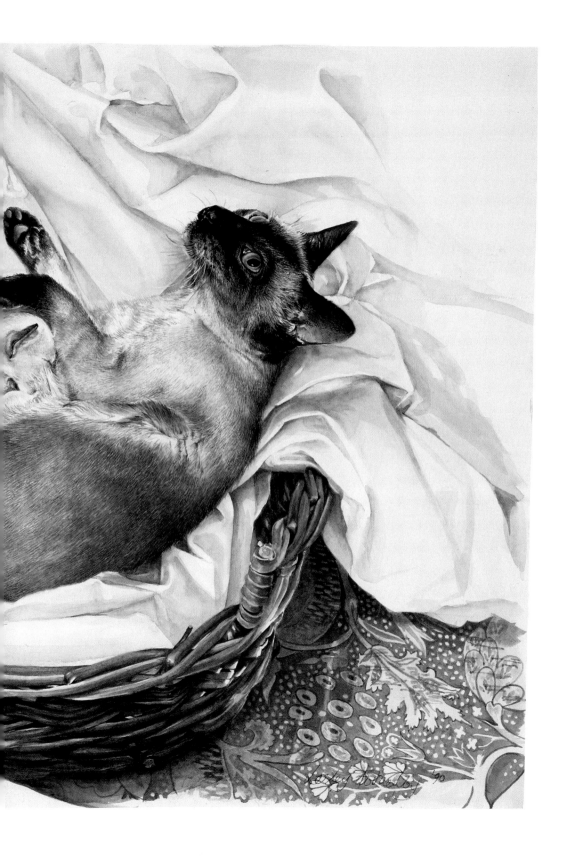

127

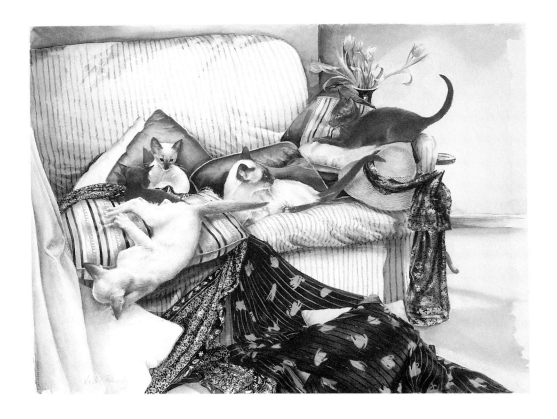

hot-pressed paper, but if I think I am going to have problems with a pose, I draw on another sheet of paper and transfer that drawing using tracing paper. The surface of water-colour paper is disturbed if you use an eraser on it.

The kittens with Wincey on the sofa (above) is an even more complicated composition. I wanted to accentuate the feeling of chaos and of cats moving in all directions, so I have used brightly coloured stripes to break up the surface of the picture. I have also tried to make the cats look as if they are reacting to each other. This particular situation did not occur, of course; I used studies done earlier and put them together – you will see, for example, that Lady appears twice in the composition. When I looked at my roughs for the painting, the composition was too flat – Lady tumbling forward pulled the foreground towards us, but there wasn't sufficient depth behind her. Her second appearance is, therefore, an attempt to rectify this and to draw our eye back into the picture.

As we saw on pages 114–16, when we looked at scale, the size of whatever we see varies greatly according to how far away or near to us it is. The kitten in the foreground of the last painting is much larger than her mother because she is nearer to us and the use of this difference in size (perspective) is the chief device we employ to give the illusion of distance.

You have already painted a cat with its immediate surroundings – a cushion, a chair or a rug perhaps. Now we are going to look further.

Make some sketches of the corner of a room or a part of your garden. Using the method on page 116, calculate the relative size of the objects around – compare a flowerpot to a gate or a seat, for example.

If you are sketching the corner of a room, take your pencil and, holding it horizontally rather than vertically in front of you, line it up with the edge of the floor as it meets the wall. You can then gauge the angle formed in the corner of the room. This is the same method we used at the beginning of the drawing section (pp. 28–29) to find the position of the cat and how some bits of it related to others. Leave all of these lines in when you draw whatever else is in the room and they will help you to see where parts of the floor appear and disappear round furniture.

When you have a completed sketch of an area, put your cat (or cats) in. It doesn't matter if this is not a tidy drawing, if things overlap or if there are lines in the wrong place which you have corrected – you will have got an idea of how objects relate within a space.

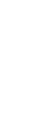

Detailed Paintings from Sketches

As we have discovered, watercolour has very particular qualities, and the way in which one paints is affected by the peculiarities of the medium. In the case of watercolour, which is transparent, this translucency gives a wonderful feeling of light. The paint can be applied quickly in broad washes of colour which the paper shines through, and we have already seen how useful it is to employ in such an immediate way to put impressions down swiftly on paper. However, we can also use watercolour to achieve more detailed work, by building up the transparent layers of colour slowly one over the other. You can achieve very brilliant hues in this way and it is a technique I have used in some of the paintings we have already looked at and in the pictures which follow.

I work on hot-pressed paper for these paintings and lightly sketch in a few lines of the composition with an F pencil. The colours which are put down have to proceed from light to dark. Because the pigment is transparent, each layer you put on will intensify the colour beneath it – it is not like

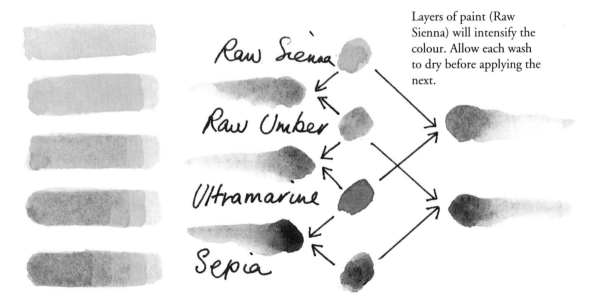

Layers of paint (Raw Sienna) will intensify the colour. Allow each wash to dry before applying the next.

Raw Sienna

Raw Umber

Ultramarine

Sepia

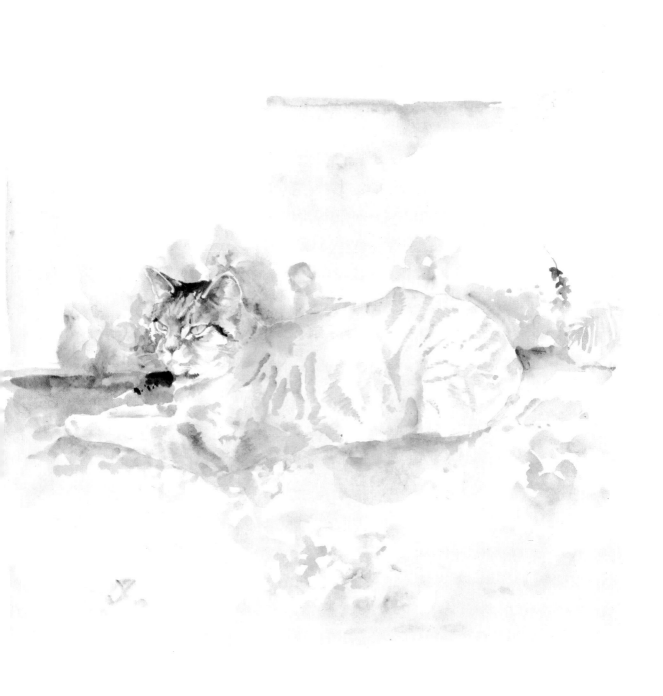

doing an oil painting, where you can cover a dark blue, for example, with a yellow and still achieve a pure yellow colour. If you cover blue with yellow in watercolour, you will only slightly modify the blue and give it a greenish tint. So, whatever you are painting, first give it a pale wash of the lightest colour you see within it and then let this and each subsequent layer dry before applying the next.

If you look ahead to page 138 in the section on how to place a drawing, you will see the picture of the tabby cat with a yellow leaf. I began that painting with washes of Raw Sienna because I wanted that yellow hue to permeate and shine through the darker colours which followed.

The painting of the same cat on page 131 shows you how a picture starts. I have just begun to build up details on the head. The colours on the left are the only ones contained in the picture except for a little Cadmium Yellow used for the eyes and the lichen. You can see some of the range of tones and colours obtainable from these by looking at the colour mixes I have made.

When using this method of working, it is tempting to concentrate so hard on one component of the picture that you build it up separately from the rest of the painting. Resist this temptation at all costs – work all over the paper. Think of your painting as you would a piece of exposed photo-graphic paper dropped into a tank of developer: if you watch it as the picture appears, you will see the whole image taking shape gradually all over the paper, from the very first pale shapes to the sharp contrasts of the fully developed photograph.

As you build up the paint, one layer on top of another, this will intensify the colour in itself, but you will probably find you also need to use slightly more pigment in the mix as you progress. Don't layer too many different colours together – this will produce a muddy effect. You can, for example, layer yellows to browns, reds or greens, layer reds to purples or mauves to blues.

In the tabby cat we looked at earlier (p. 131), I worked from yellows, leaving some of the body white, through Raw Umber (yellowish brown) to dark brown (Sepia) and almost black (Sepia and Ultramarine).

Even though these pictures require fine brush marks for detail and texture, I continued to use a No 6 or 8 sable brush until the very last touches. The point of the brush is fine enough to paint thin lines so long as

you don't press too hard, and the large reservoir of paint held within the body of the brush is invaluable in achieving a good flow of colour. When I do the finishing touches, the final texture on the coat and any body colour I may be using, I change to a No 1 or 2 brush and mix much less water with the paint. This is the only stage at which you want a fairly dry effect.

Try the exercise illustrated on pages 130–31 for yourself.

Composition

The more cats you put into a painting, the more carefully you must consider how they relate to each other and to their surroundings. Without a point to focus on and start to explore the picture from, a complicated painting such as the one overleaf with four cats can become confused – the viewer would not be able to decide what to look at first.

I have used the large yellow roses as a focus for the cats' attention in the painting overleaf. This draws the three cats on the right of the picture together as they stare at the flowers, whilst the cat on the left looks out of the frame.

Our eye goes first to the heads of the three cats looking up and, from there, to the flowers above them. These flowers are at the top of a curve of foliage which partly encloses them. We are then led down through the device of this curve to the cat sitting amongst the daisies and thence back along the path to the gate in the background.

I did several studies of the cats and the garden before embarking on this picture – some of them you can see earlier in this book. Of the profusion of plants in the garden, I chose to concentrate on those with yellow, orange and blue flowers. Limiting the colours in this way gives unity to a picture. The orange flowers echo the colour of the dominant cat, and the combination of blue and orange (complementary colours) is usually a successful one.

In the foreground the small flowers of the lobelia, which are a vivid Ultramarine, draw our eye forward and help give depth to the picture; they also help to break up what would otherwise be a hard line where the plants in the tub stop and the path starts.

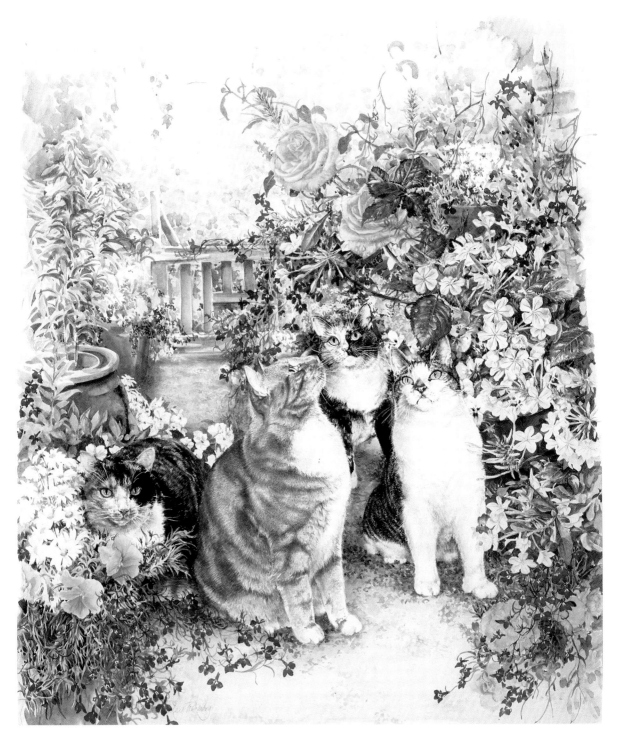

134

Placing a Drawing on a Page

The drawings overleaf are small sketches grouped together on a single page. There was a practical reason for this composition: I had to do the drawings quickly and I didn't want to start anew with each movement. However, there are advantages, apart from the practical ones, in seeing all the drawings together. Firstly we are more aware of the fluid movement of the cat as we look from one drawing to another (rather like looking at stills from a cine film) and secondly they work as a composition of shapes within the rectangle of the drawing paper.

When you are making a drawing, it is easy to disregard how you're placing the drawing on the paper and what the composition will look like.

If you are doing just one drawing on a sheet of paper, don't make it too small because it will look lost and, when you try to work on it, you'll find the size will restrict you – there won't be enough space to put in details of shading, etc.

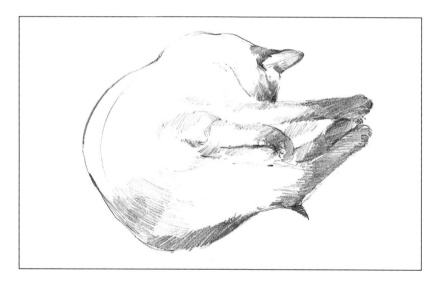

This drawing is placed almost centrally on the paper with space all around, but it is large enough to hold our interest. You don't necessarily have to fit all of the cat on to the page, however.

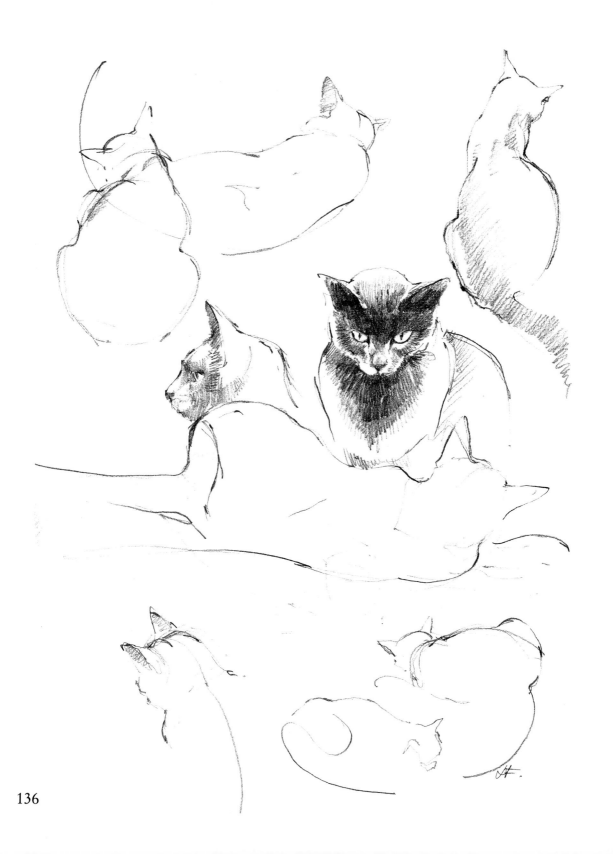

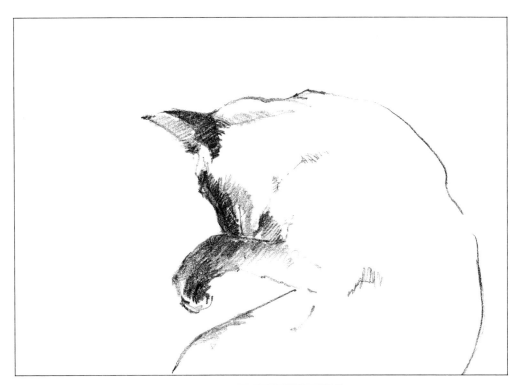

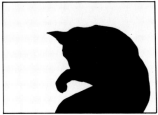

Only half the cat is seen above and that half takes up an even larger proportion of the paper than does the previous sketch. I have placed it off-centre because most of the interest is in the head and paw on the left-hand side of the drawing; to have pulled this dark area any further to the left would have given the impression that the drawing was going to topple out of the page. It would have been unbalanced.

If you think back to the cat on the windowsill (pp. 34–37) and the exercises you did to show the space behind the objects on the windowsill, you will see how important the area of blank paper is in the diagram above.

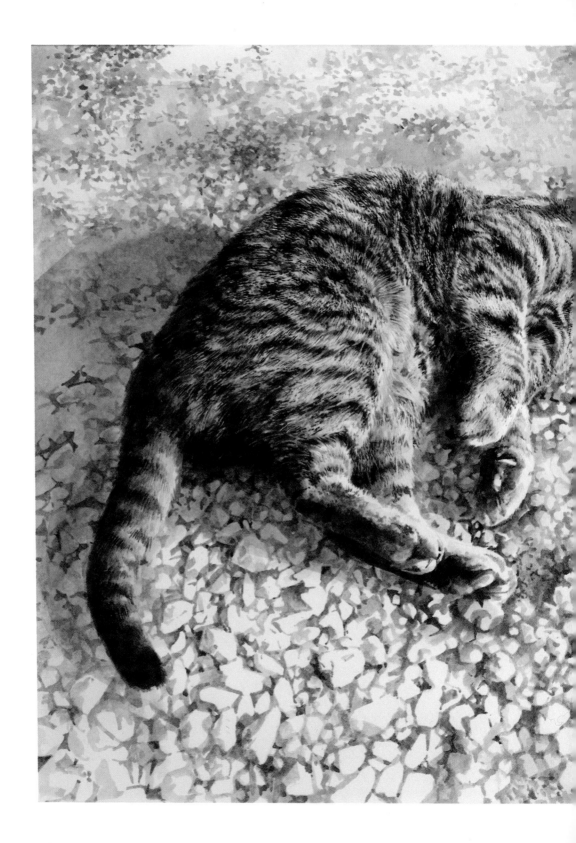

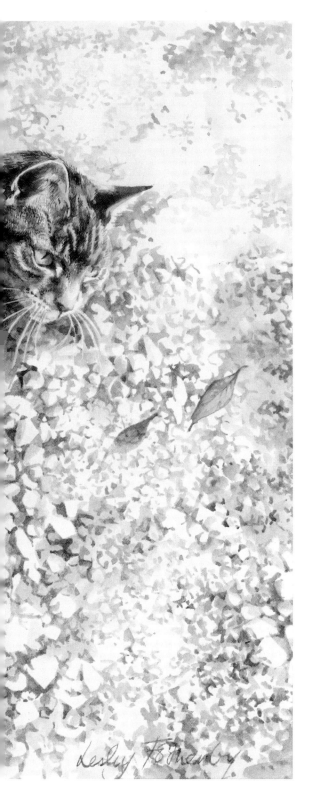

Lesley Fotherby

The drawings on this page also concentrate on the top part of the cat's body. I was interested in the layers of tail, paws and ear, and in the odd interplay of shapes they made; this is the most important element in this drawing because there is not such a strong silhouette as in the last one. To counteract the linear puzzle and to pull the eye downwards, I put in a little of the pattern on the chair beneath the cat. As she moved in her sleep, the

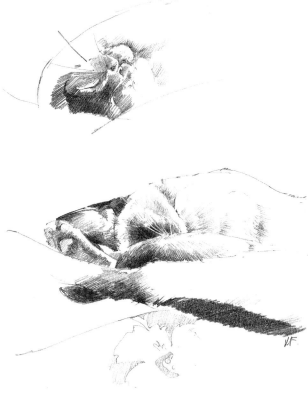

position of her paws changed and I could see her tilted head. This image fitted in quite well above the first pose. They are two separate drawings on the same page, but are connected in that each helps to explain the other.

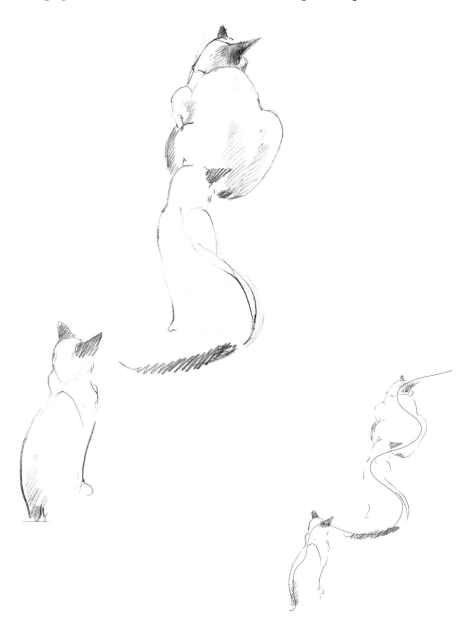

Two of the sketches opposite overlap – the drawings are not separate, as were the previous ones. I have deliberately placed them on the page so that our eye follows through from the line of the first cat's back to its right ear, thence to the tail of the second cat and the ears of the third. This makes a fluid line across the page.

You can experiment with composition by cutting a rectangular window in a piece of stiff paper. Make the hole the same proportions as your drawing paper, but smaller in size – 5 cm x 7.5 cm approx. is fine. Hold this up between yourself and what you want to draw: move it towards you if you want to see more of your subject, and away if you need to close in on a particular part. You can move your 'viewfinder' around to choose precisely what you want to put down on paper without the distraction of surroundings.

Summary

The most fascinating aspect of looking at drawings and paintings done of the same subject by a group of people is seeing the range of their interpretations. I don't mean how good they are individually at putting down on paper what they see, but how they use their materials to express their own very special experience and ideas. You will all have different experiences and expertise to tap, and this will show in your work. I know that by now you will have found you are better at drawing and painting than you thought you were – the real barrier to overcome is the fear of failure.

I've tried to show you the techniques which work for me. Many of them are very basic and apply to drawing and painting any subject – they are tools to master, use and discard if you wish (you can only break the rules effectively if you know what they are). Take from the information offered what suits and helps *you*, and then you'll attain your own individual style.

Most importantly, enjoy what you are doing. The physical act of drawing or painting is pleasurable and sensual as well as being an intellectual exercise. I still find it exciting to put watercolour paint on paper, and watching colours blend and vibrate with each other. The pleasure you derive from sketching and painting will show in your pictures, as will the enjoyment you derive from your relationship with your animals. I just hope this is not outweighed by the frustrations of their inevitable lack of co-operation!

Index

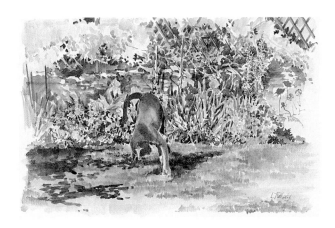